DONATELLO IN TUSCANY
ITINERARIES

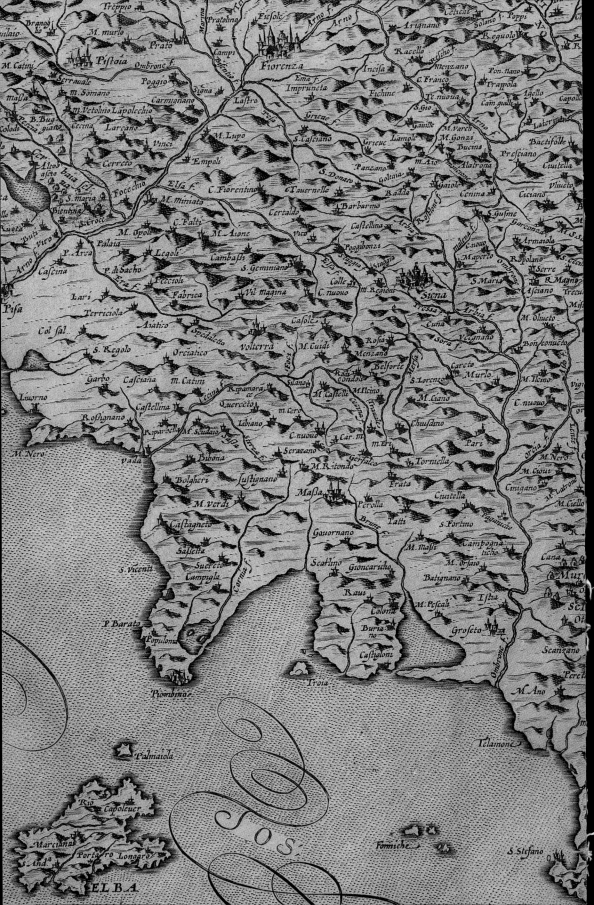

DONATELLO
ITINERARIES
TUSCANY

edited by
FRANCESCO CAGLIOTI

FONDAZIONE
PALAZZO
STROZZI

Marsilio Arte

DONATELLO
ITINERARIES
TUSCANY

Curated by
Francesco Caglioti

Promoted and organised by

FONDAZIONE
PALAZZO
STROZZI

With the support of

CITTÀ METROPOLITANA
DI FIRENZE

BEYFIN

Media Partner

QN LA NAZIONE

Texts
Francesco Caglioti
Gabriele Fattorini
Aldo Galli
Neville Rowley

Acknowledgements
Our gratitude for their precious cooperation
goes to: Archdiocese of Florence, Archdiocese
of Siena–Colle di Val d'Elsa–Montalcino,
Comune di Firenze, Comune di Prato, Comune
di Torrita di Siena, Istituto per la Valorizzazione
delle Abbazie Storiche della Toscana, Musei
del Bargello, Opera Medicea Laurenziana,
Opera di Santa Croce, Opera di Santa Maria
del Fiore, Opera del Duomo di Prato, Opera
della Metropolitana di Siena, Polo Museale della
Toscana.

The project is designed to tie in
with the exhibition

Donatello, the Renaissance
Florence, Palazzo Strozzi
and Museo Nazionale del Bargello
19 March–31 July 2022

Curated by
Francesco Caglioti

Promoted and organised by
Fondazione Palazzo Strozzi
and Musei del Bargello

In collaboration with
Staatliche Museen zu Berlin,
Victoria and Albert Museum, London
and
Fondo Edifici di Culto, Ministry of the Interior

Main Supporter
Fondazione CR Firenze

Supporters
Comune di Firenze, Regione Toscana,
Camera di Commercio di Firenze,
Palazzo Strozzi Partners Committee

Main Partner
Intesa Sanpaolo

With the support of
Maria Manetti Shrem, Bank of America, ENEL

A seminal exhibition, *Donatello, the Renaissance*, devoted to a master whose revolutionary innovations left their mark on the whole history of Western art, could hardly be limited to the two venues, however rich in artworks, of Palazzo Strozzi and the Museo del Bargello. Donatello's legacy is far too important, drawing as he does on classical antiquity and the early Middle Ages to attain a modernity that means his work even has close affinities with our own sensibility today.

During each exhibition, the tradition of Palazzo Strozzi's *Fuorimostra* suggests itineraries covering the whole of Tuscany, so connecting the current event with museums, cultural institutions and regional partners. In keeping with this tradition, the project *Donatello in Tuscany* expresses one of the cardinal values of the Fondazione Palazzo Strozzi by enhancing the value of Florence's metropolitan area and Tuscany as a whole, creating synergies and partnerships that promote the region's culture.

Hence the idea of this publication, edited by Francesco Caglioti and with contributions by Gabriele Fattorini, Aldo Galli and Neville Rowley. It presents an itinerary that takes in works preserved in the region, with entries devoted to each place accompanied by a wealth of illustrations. This is a book that lives on after the exhibition, encouraging visitors to discover more than fifty works by Donatello spread across Tuscany, further immersing themselves in the artist's universe and exploring its contexts in a series of exhibits on a regional scale.

A restless spirit, extraordinary for his fertility and range of invention, Donatello has left works in many parts of Italy, but those preserved in Tuscany surpass all imagination. Throughout his life he was devoted in particular to Florence, where he was born, grew up, trained and left numerous masterpieces that provided the rising generations with an abundance of ideas. The account presented in this volume encompasses twenty-one places in Arezzo, Pisa, Pontorme, Prato, Siena, Torrita di Siena, as well as Florence. Its itinerary enables us to understand Donatello's ability to experiment with the most diverse genres, purposes, materials, techniques and formats, working with marble, *pietra di macigno* and coloured stone, bronze, terracotta, wood, stucco, glazed and gilded ceramic mosaic tiles, often in multi-media works, and always achieving extraordinary expressive effects.

Donatello's was a modern and transgressive spirit ('frank and lawless', as Caglioti puts it), one who constantly questioned himself and created an invariably unpredictable style, challenging the modes and the taste of the age to attain a new way of seeing and understanding the world.

ARTURO GALANSINO
Director General Fondazione Palazzo Strozzi

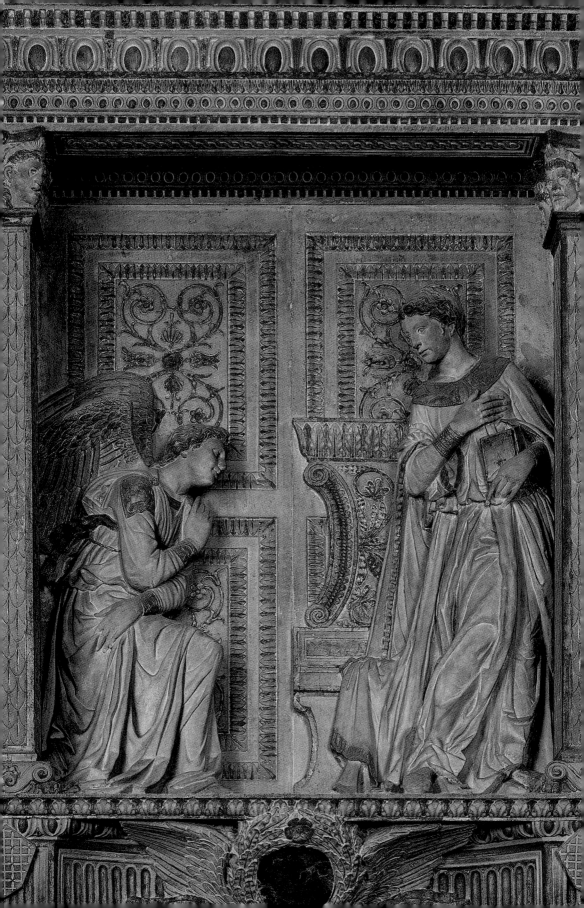

CONTENTS

Introductory note

FRANCESCO CAGLIOTI

Seeking out and admiring Donatello's works scattered across Florence and Tuscany is an easy and above all exhilarating experience, though it involves the visitor in some passionate mental juggling with the times of history and historic places. As early as 1416, in fact, when he was only thirty, some of his masterpieces, devised and created to be seen in certain specific ambient conditions and not others, began to be moved about for institutional reasons or because of changes of government, then from shifts in taste, then again because of the great nineteenth-century development of museums, and finally to protect them from the weather.

The extreme case is the bronze *David*, which at various times has had six different locations (the Medici's 'Old House', Palazzo Medici, later Palazzo Riccardi, the Signoria, Palazzo Pitti, the Uffizi and finally the Bargello), and been displayed in no fewer than seven or eight different ways. At the opposite extreme, the baptismal font in Siena and the basilica of San Lorenzo in Florence retain their original structures almost intact, with only minor losses. These two poles enclose a very varied series of instances, including works whose original position is now marked by replacement copies (in particular on Giotto's campanile) and others that have left gaps or been replaced by quite different artworks (as in Palazzo Medici). But there are also contexts, such as the Piazza and the Palazzo della Signoria or the Door of the Mandorla of the cathedral, where replicas are available for certain figures and not for others. Among copies of individual works, some are even hybrid, as is for Orsanmichele, whose statues have been museumized while their tabernacles remain outside, or the *Pulpit of the Holy Girdle* in Prato, whose more strictly figurative elements are in the museum while the other parts remain in their original place.

Those who use these *Itineraries* will always find cross-references in the texts redirecting them, for example, from Palazzo Medici to Palazzo Vecchio, or from this to the Bargello, or from Santa Maria del Fiore to its Museo dell'Opera and vice versa. But the book has this intimate coherence of approach: almost every object is treated more fully in the section on its original location, which is especially true of those museumized from the late nineteenth century to the present. Some very important historical sites, such as Palazzo Medici, where almost every trace of Donatello's presence has been lost, are also presented, but sufficiently to guide the tourist, who will find the works taken from them at the Signoria and the Bargello.

Finally, the stages of the *Itineraries* are arranged parallel with Donatello's life, resting on its chronology respectively by the numerical sequence of the first section and the alphabetical order of the second.

FLORENCE

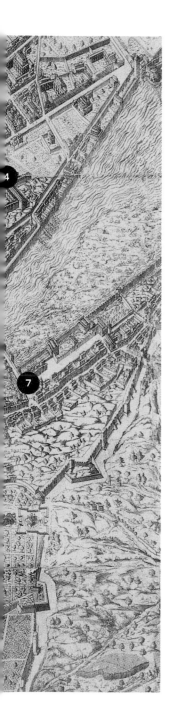

Baptistery

Francesco Caglioti

In Donatello's day, the octagonal temple of San Giovanni, the baptistery of all the Florentines (fig. 1), displayed such splendour and solemnity that it could sustain the legend, popularly widespread, that it had been a pagan place of worship of the Roman city, sacred to Mars: a sanctuary, in short, later converted to Christianity like the rotunda of the Pantheon in Rome. But the building that we still see today dates from the eleventh century, the dawn of Tuscan Romanesque. And its absolute centrality in the city's plan and topography and in the life of its citizens continuously elicited the care of the Arte dei Mercatanti or Arte di Calimàla, responsible for its fabric through the Opera di San Giovanni, starting in the following century: first the pervasive mosaic decorations in the dome and in the vault of the presbytery, and then, in the early fourteenth century, the marble figures over the doors (Tino di Camaino) and the two leaves in bronze of the first door with stories of the saint (Andrea Pisano).

Donatello was involved in working on the baptistery on no fewer than four occasions, always for different purposes, which have left equally varied traces.

The first was between 1404 and 1407, as an assistant in the workshop of Lorenzo Ghiberti, then at work on the North Door (1403–24). This was the culmination of Donatello's training in metalworking. But the master craftsman's consummate ability to give the whole a very coherent imprint prevents us from identifying the role of his pupil and future rival. The echoes of this experience can rather be seen in his first works as an independent sculptor: the *Prophet* on the left and the *Vir dolorum* for the Door of the Mandorla of the cathedral (1406 and 1408; pp. 18–21), the marble *David* (1408–9 and 1416; pp. 21–3 and 70–1) and the wooden *Crucifix* for Santa Croce (c. 1408; pp. 51–3).

The second circumstance, almost twenty years later, was the most significant (c. 1422–8): the **tomb** of the Campanian cardinal Baldassare

[1]

1.
Interior towards
the west (presbytery)

Coscia, who was the antipope John XXIII from 1410 to June 1419 (fig. 2). Dying in Florence in December of the same year, Coscia had formed such close ties in the circles of high finance in the city that he managed to obtain, through his four executors (including Niccolò da Uzzano and Giovanni di Bicci de' Medici), the unprecedented privilege of burial in the baptistery. Since, in return, the monument was required to be small, Donatello, entrusted with the commission probably through the Medici, made a virtue of necessity by setting it between two columns of the Romanesque order, which thus became structural and symbolic elements of the tomb itself. Again playing with intelligent illusionism on the basis of the least possible disturbance to the public, the master ostentatiously placed before the fixed and lintelled structure of the tomb a canopy as of cloth, as if it was a temporary display. In fact this mass wholly of marble with the recumbent effigy of bronze gilt resting on an ungilt bronze cushion and drapery is luxurious to a rare degree. The first funerary monument of the Renaissance, it combines a traditional solution, such as the suspended sarcophagus (inspired once again by the limits of the space), with new solutions such as the niches decorated with conches for sacred subjects (the *Virgin and Child* at the top and, below, the three *Theological Virtues*, namely *Charity* between *Faith* and *Hope*). In 1425 Donatello was joined by his young partner Michelozzo, who all too often, due to his subsequent success as an architect, has been credited with a role in the design of this work. Rather he must have been the conscientious leader of a close-knit team of collaborators, himself included, who followed Donatello's drawings and models. Donatello's own hand appears openly only in the figure of the deceased, his face still clearly bearing the imprint of wounded pride at the loss of his papal dignity.

The third link between Donatello and the baptistery is in the famous wooden **Mary Magdalene** today in the Museo dell'Opera del Duomo,

[2]

[3]

2.
Donatello
and Michelozzo,
*Tomb of Cardinal
Baldassare Coscia,
Formerly the Antipope
John XXIII*, c. 1422–8

3.
Mary Magdalene,
c. 1440–2, Florence,
Museo dell'Opera
di Santa Maria
del Fiore

whose style suggests a date of about 1440–2 (fig. 3). Whether it was really intended immediately for a particular altar in the sanctuary (at whose expense?) is not really clear. But a document from 1500 mentions its presence in the baptistery as customary, so it is better to accept this as its original location. The loss of Brunelleschi's wooden *Mary Magdalene* in Santo Spirito, destroyed by fire in 1471, can never be sufficiently regretted. The textbook comparison between the wooden *Crucifixes* by the two sculptor friends in Santa Croce and Santa Maria Novella leads us to imagine Filippo's saint as an austere and suffering penitent, but still with aristocratic features and a stable pose. Donatello, by contrast, managed to instil his figure with all the sense of ancient beauty made haggard and tottering by time and privations, but still stubbornly sustained by faith.

The last connection between Donatello and the baptistery was a missed opportunity. The bronze *Baptist*, which since 1501 can be admired in its present location in a chapel of its own in Siena Cathedral (pp. 146–7 and 148–9), was left as a pledge by the master with the local Opera in 1461, when he fled the city after four years of hard work eagerly desired by the Sienese but fruitless. Arriving hurriedly in Siena from Florence in 1457, Donatello brought with him this statue that the Opera had never asked for, and in 1458, in correspondence with the Gonzaga family of Mantua, he treated it as his own, a work that would accompany him if he were to move to the banks of the Mincio. Such an expensive sculpture, however, must have been made for a first-rate public commission. And since the years from about 1455 to 1457, to which the figure must belong, followed the completion of the Door of Paradise, the return of Donatello from Padua and the death of Ghiberti, everything suggests that the *Baptist* is the only outcome of a first attempt by the Opera di San Giovanni, ending in a dispute, to renew the old marbles by Tino di Camaino over the baptistery doors. They were replaced only in the sixteenth century with three groups provided by Andrea Sansovino, Giovanfrancesco Rustici and Vincenzo Danti. Donatello's statue perfectly heralds the protagonist of Rustici's bronze *Baptist Preaching* over the North Door.

Donatello in the baptistery

Donatello and Michelozzo
Tomb of Cardinal Baldassare Coscia, Formerly the Antipope John XXIII, c. 1422–8
[2]

Santa Maria del Fiore

Francesco Caglioti

1.
Door of the Mandorla,
1391–1422
and 1489–91

Florence Cathedral, Santa Maria del Fiore (originally Santa Reparata), was the most important place in Donatello's life and career. Here he would have received his first training as a carver of stone and marble. Here he produced his first public work in 1406. And here, above all, he was active, in preference to any other site, in the first thirty years or so of his profession, until 1439, producing a broad and original array of masterpieces, and developing his individual style and reputation as well as the new forms of Renaissance sculpture. Donatello's relations with the Opera di Santa Maria del Fiore, responsible, then as now, for managing the impressive building and maintenance work on the cathedral and its campanile, and governed at that time by the powerful Arte della Lana, apparently remained good and indeed constant even after 1439 and until the end of his life (1466). Yet he failed to produce any other major work for the cathedral, including the notable commissions he was given from 1437 on.

Early Christian in origin, the cathedral of Santa Reparata was completely rebuilt on Gothic principles starting at the end of the thirteenth century, with an ambition of plan and structure that, growing gradually in the course of the fourteenth century, came to create one of the world's greatest Christian places of worship. When the sculptor began working in his craft, at the end of the fourteenth century, the Gothic building, which we still admire today, was far from complete, either in its volume or its principal external and internal ornaments. But Donatello would then have had the fortune to observe, with Brunelleschi's dome, inaugurated in 1436, the culminating stage of the history of its construction. Thirty years before this, for a sculptor in marble with a figurative talent such as Donatello's, there were not many tasks to be performed inside the liturgical space, while there were some highly varied works to be made for the exterior. The rich facade started by Arnolfo di Cambio – the original

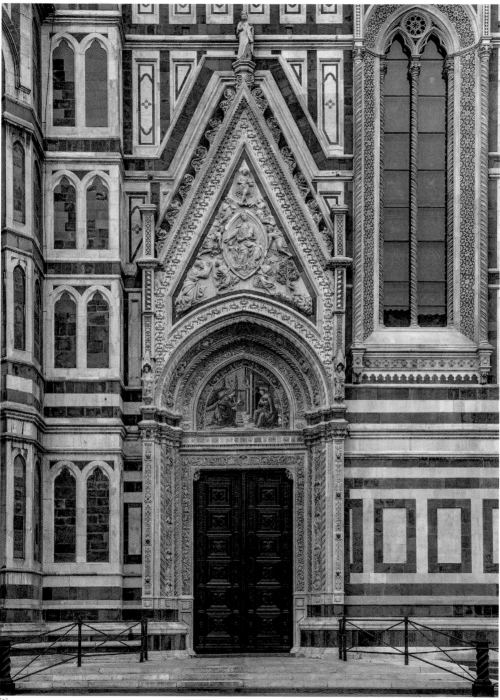

[1]

Santa Maria del Fiore

master builder of the new cathedral – to accommodate sculptures and polychrome inlay required myriads of statues on several levels (only the three portals were finished); of the large side doors to the body of the cathedral (two on the north side and two on the south), the last had recently been begun to the northeast, towards the church of the Annunziata; twelve statues of *Prophets* were planned on the twelve buttresses or 'spurs' of the three tribunes around the octagonal edge prepared for the dome; and on Giotto's campanile, of sixteen niches for as many statues of *Prophets*, in the third register of its iconographic apparatus, eight were empty.

IN THE INNER GALLERY
Margrit Lisner (1977), however, conjectured that the young sculptor may have produced his earliest work quietly inside the church, between around 1402 and 1406. On the gallery made of *macigno* stone, the labour of many hands and many decades, which runs like a walkway resting on corbels all around the interior (1364–1421), appear the busts of a young man and a woman carved in bas-relief, the first in the north-west section under the dome, the second in the north tribune. They seem the work of a chisel that rose above the routine level of the series and heralded Donatello's future expressive energy.

IN THE DOOR OF THE MANDORLA
Donatello officially produced his first work, however, in 1406, as recorded in payments by the Opera, on the portal towards the Annunziata, known as the Door of the Mandorla after it was completed with the pediment of the *Assumption of the Virgin* between 1421 and 1422. Work on the door (fig. 1), erected from 1391 on, among other late Gothic masters had involved two prominent figures, Giovanni d'Ambrogio and Niccolò di Pietro Lamberti, with whom the young sculptor very likely served his apprenticeship. At the sides of a strongly splayed rectangular passage, around hexagonal tiles from which look out half-length figures of angels bearing scrolls, appears a lavish tangle of vegetation in ancient style. Inhabited by human bodies, naked or draped in the most unexpected poses, scholars have always seen this as the forcing ground of that return to antiquity that would be practised almost extensively by Donatello's generation. In 1397 work on the door stopped for a few years, while it continued as usual on other parts of the building. The whole entrance for the faithful and four elements of the ogival arch designed to surmount it were then ready: an *Archangel Gabriel* and a *Virgin Annunciate* by the master craftsman Giovanni d'Ambrogio (today in the Museo dell'Opera), to be set in the compartment of the arch; and two *Prophets* by Lorenzo, Giovanni's son, in the aedicules at its sides, above the external uprights

2.
Young Prophet, 1406,
Florence, Museo
dell'Opera di Santa
Maria del Fiore

3.
Nanni di Banco,
Young Prophet,
c. 1415–20, Florence,
Museo dell'Opera di
Santa Maria del Fiore

[2]

[3]

(still in place today). While waiting for the arch to be built, the two figures of the *Annunciation,* free-standing and manageable statues, were set up inside the church, on an altar by the counterfacade, where they fitted in easily, raising some uncertainty among the administrators of the Opera del Duomo, and certainly the clergy, as to whether it was advisable to leave them there for good or install them sooner or later in the portal.

When work resumed on the door late in 1404, and Lamberti on the left and Antonio di Banco and his son Nanni on the right respectively were assigned the two halves of the embrasure that, with the branches and hexagons of the angels holding scrolls, continued and concluded the vertical splayed jambs below, the twenty-year-old Donatello joined the work. The records of the Opera for these months have not survived sufficiently, as for other periods before and after, but it is certain that in 1406 an instalment was paid to him for *Prophets* (evidently two) who at that time were not urgent, and who only at the end of work on the door, fifteen years later, were placed on the two side pinnacles, higher than the mandorla of the *Assumption*. After lengthy discussion among scholars, it is now agreed that the **Prophet** formerly on top of the left pinnacle alone is by Donatello, and that the other *Prophet* for the right pinnacle was sculpted by Nanni di

Banco (today they are both in the Museo dell'Opera; figs. 2–3). Apart from the difference in workmanship (contrasting with the original commission given to Donatello alone), historiographical disputes over these two statues have been fuelled by seeing that Nanni's figure, although unusually very young, has all the attributes of a prophet (starting from the scroll), while Donatello's also adolescent figure, which does not hold a scroll, has the ambiguous appearance of an archangel, with a wreath of vegetation on his head, and is making a slight stepping movement, like a messenger. If we consider that, when the arch was finished, the *Annunciation* by Giovanni d'Ambrogio would have been put in place, and that Donatello, although assigned two *Prophets*, made only one with the completely unusual feature observed, and without suffering any negative consequence for not working on the second statue, a likely reconstruction of events is as follows. In the months when Lamberti and the Banchi were beginning the archivolt, Donatello received a commission for an *Annunciation* to replace Giovanni d'Ambrogio's, of the same dimensions. But very soon, after a summary and yet decisive roughing out of the *Archangel*, the Opera changed its mind and favoured the *Annunciation* by Giovanni, so that Donatello was urged, before it was too late, to convert the block roughed out into one of two *Prophets* for the pediment, already planned for some time, or now devised due to that circumstance.

Such a succession of decisions, much more likely to occur during work on a building like the cathedral than it is easy to recount today, explains a chance but crucial passage in Donatello's emergence as a sculptor. Perhaps for the first time in the history of biblical iconography, he found himself representing a youthful *Prophet*, so highly appreciated by the Opera that Nanni di Banco was also asked to sculpt one. Nanni did not do the statue immediately (there was no need), but in due course, almost ten years later, while working on the crowning of the *Assumption*. This meant he had the advantage of being able to make a *Young Prophet* not only firmly placed and holding a scroll, but also no longer wholly Gothic, thanks to the lesson that Donatello had in the meantime imparted to his colleagues with his first three statues for Orsanmichele (c. 1410–7; pp. 56–63, 65 and 71). By contrast, Donatello's youthful *Prophet* is the smaller and younger brother of the marble *David* that he was soon to carve for one of the spurs around the void for the dome. And it has all the cadences of drapery found in the figures by Lorenzo Ghiberti, in whose work on the North Door of the baptistery Donatello was involved in those same years (1404–7), completing his internship as a goldsmith and metalworker (p. 12).

The central role in the Door of the Mandorla attributed by the Opera to the young master by entrusting him with the two statues for the arch was confirmed at the beginning of 1408. In those months Donatello

[4]

4.
Vir dolorum, 1408,
Florence, Museo
dell'Opera di Santa
Maria del Fiore

sculpted the **Vir dolorum** for the keystone of that same lunette, in the form of the Redeemer with outstretched arms, who also looks out from a hexagon, as if it were from the edge of a sarcophagus (fig. 4). This Christ irresistibly conjures up the 'peasant' carved on the wooden *Crucifix* for the basilica of Santa Croce (pp. 51–3), which should therefore be dated to the same period. But the greater precision of marble compared to wood, in the hands of the same expert, enabled him to sculpt a body rich in muscular and epidermal nuances, so revealing forever the incomparable virtuoso in the craft of stoneworker. The *Vir dolorum*, exhibited today in the Museo dell'Opera like almost all of Donatello's works for the cathedral, has on the left, asymmetrically, a vegetable ornamental attachment that is missing on the right. This technical device, which almost no one would have perceived in its final position, was due, as the documents make clear, to the need to correct a mistake that Lamberti had made in calculating the design and measurements of his ornaments for the same archivolt.

THE MARBLE *DAVID*

As soon as Donatello had completed the *Vir dolorum*, the Opera assigned him the **David** for one of the first two spurs around the dome, those to the northwest, closest to the Door of the Mandorla (February 1408; fig. 5). A month earlier, Nanni, a friend and never a rival of Donatello, had received the assignment for the companion piece of *Isaiah*. Encouraged by the biblical account, which tells the story of David from childhood to the end, Donatello for the first time in statuary depicted the adolescent shepherd who triumphs over Goliath, already beheaded, not the royal Psalmist. This was an epochal turning point not only in the history of Western art, but even more in the development of the collective and official imagery of the Republic of Florence, which a few years later would

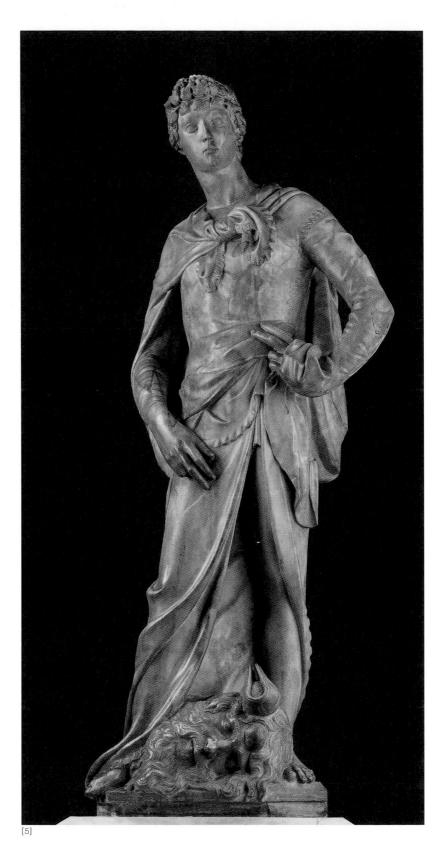

[5]

identify this sculpture as a symbol of its freedom and the struggle against all tyrants. Like the *Crucifix* in Santa Croce, the Gothic lines of the body and especially of the drapery cannot contain all the vitality that Donatello managed to impress on the young hero, focusing his emotional and physical surge of pride in the defiant gesture of the left hand resting on his hip.

As with the anomalous forms of the *Young Prophet*, the special success of the *David* (which Nanni di Banco promptly imitated in a young *Isaiah* of a kind never seen before) was again decided by chance, because *David* and *Isaiah*, both just under two meters high, in early summer of 1409 were put to the test on the buttresses and proved completely unsuitable at that height. This meant they could now be placed where they would be more easily seen. The *Isaiah*, however, was half-concealed among the many statues on Arnolfo's facade, in the aedicule on the second level of the buttress between the central and right portal. (Here it was eventually given the name *Daniel*, better suited to a young man, and an attribution to Donatello. Since 1587 it has been in the cathedral, at the beginning of the right nave.) The *David*, however, was reserved for prominent display, and therefore also had to be reworked in those parts skilfully left unfinished – especially towards the bottom – since it was originally meant to be placed high up. For these reasons it is recorded in 1412, before its new location had been decided, among the figures of the Opera that Donatello was working on, and this has led to many misunderstandings in the modern bibliography (which has imagined a second *David*). In 1416, after Donatello had spent several days, together with some of 'his assistants', 'in finishing and adapting' the statue, the *David* was placed in the first official chamber of the apartment of the gonfalonier and the eight priors of the Republic on the second floor of Palazzo della Signoria (now the Sala dei Gigli in Palazzo Vecchio; p. 114). There it remained on display for at least two centuries, dominating the room from above two brackets affixed to a wall adorned with golden lilies on a blue field (as the whole chamber would later be), and accompanied by a Latin epigraph, perhaps by Leonardo Bruni, exalting David's prowess in civic terms, as a guarantee of the victory that God bestows on those who fight courageously for their country. In the heyday of the Medici Grand Duchy, in the early seventeenth century, the statue was moved to the Galleria degli Uffizi, and from here, in 1873, it was taken to the new Museo Nazionale del Bargello, where it is still one of the high points of a visit, in the Salone di Donatello (pp. 70–1).

THE LOST TERRACOTTA *JOSHUA*
Before 1416 the sculptor had completed two other great figures for the Opera.

The first to be consigned, but the second to be commissioned (sum-

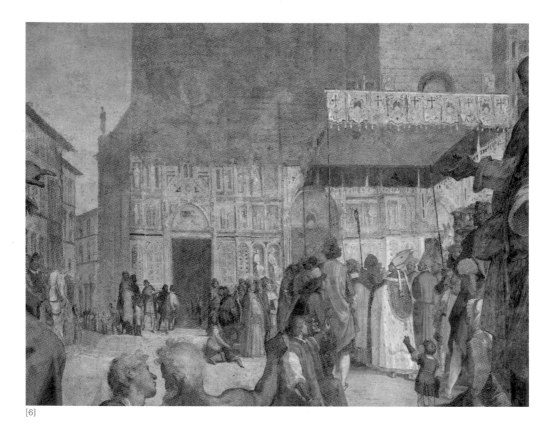

[6]

6.
Bernardino Poccetti,
*Antonino Pierozzi,
Ordained Archbishop,
Entering Florence
Cathedral*, c. 1604–5,
detail showing
a 'colossus' by
Donatello on the
second buttress
of the north tribune
of the cathedral,
Florence, Museo di
San Marco, Chiostro
di Sant'Antonino

mer 1409), was the semi-colossal *Joshua*, which between 1410 and 1412 was erected and finished on the first spur, in the place of the *David* or, more likely, *Isaiah*. The biblical general, now almost five and a half meters high and worthy to be dubbed the 'Giant', as he was soon commonly called, was also a great innovation, since there is no trace in all the Middle Ages, whether in written sources or archaeological remains, of any work of art calling for such a commitment, or even a lesser one, being modelled in clay. Hence it is regrettable that no clear visual record of it remains. Having been covered with gesso and whitewash to create the impression of marble, it was gradually weathered away until it disappeared completely between the seventeenth and eighteenth centuries. A detail in a fresco by Bernardino Poccetti in the Chiostro di Sant'Antonino in San Marco (c. 1604–5; fig. 6), invariably connected with it, portrays a similar statue on the next spur (unless Poccetti has mistaken the perspective). The importance of the *Joshua* is hardly negligible, because it is also the first certain documentation of Donatello as a coroplast, meaning a modeller of works in clay. Studies in recent decades have rediscovered and reassessed this activity increasingly carefully from his youthful years, seeing it as the start of the veritable rebirth of an ancient artistic practice that Pliny the Elder mentions adequately in his *Natural History* and that, after the developments mentioned here, has continued until the present. Everything suggests that a far from secondary part in this recovery was played by Brunelleschi. In 1412 he had been engaged in a sculpture *compagnia* (partnership) with Donatello for some years (although apparently

devoted mainly to works for Orsanmichele), and he was commissioned in 1415 by the Opera, together with his partner, to study new technical expedients to place all the 'giants' that they required on the spurs, without using costly and problematic marble. Brunelleschi's biography written by Antonio Manetti in the second half of the fifteenth century and other Renaissance narrative sources agree, moreover, in representing Filippo not only as a close friend of Donatello's, but also his principal artistic and cultural mentor in his early life, surpassing the technical training he gained as an adolescent follower of Giovanni d'Ambrogio, Lamberti or Ghiberti.

THE *SAINT JOHN THE EVANGELIST*

For almost five years after the *Joshua*, Donatello did not produce any finished work for the Opera, because he was busy above all with the *Saint Peter* and *Saint Mark* for Orsanmichele (pp. 56–9, 63 and 65). But from December 1408, while he was sculpting the *David*, he had committed himself to creating the *Saint John the Evangelist* in marble for one of the four niches with the four *Evangelists* on the first level of Arnolfo's facade, two on the left and two on the right of the main portal (fig. 7). He received the assignment together with Lamberti (*Saint Mark*) and Nanni di Banco (*Saint Luke*). The three masters were promised that the sculptor of the most successful figure would also be given the fourth, but instead the *Saint Matthew* was soon reassigned to Bernardo Ciuffagni (1410). This sculptor, whom we now meet for the first time, for almost the next three decades would be one of those most frequently connected with Donatello's work in the cathedral. Far less skilful than his colleagues mentioned so far, as well as the others who would participate in the work on the marbles for the exterior of the cathedral and the campanile (Giuliano da Poggibonsi, Nanni di Bartolo), Ciuffagni nevertheless proved very adept for a long time at procuring some of the most coveted commissions and fees as well as the largest blocks, but also at hindering with his claims, and especially his failures, the development of the statuary work devised to be distributed among several masters then working on parallel commissions. Similar inconveniences did not arise with the *Evangelists*, but they emerged later, with the *Prophets* on the campanile, and affected the schedule of Donatello's work. In the meantime, as Lamberti with his *Saint Mark* (fig. 9) was producing a late Gothic masterpiece entrammelled in decorative indulgences – melodious no less than haughty – of hair, beard and drapery, Donatello, thanks to a very courageous anamorphosis, was infusing his awesome **Saint John** (fig. 8) with the sense of an uncontrollable plastic mass flowing overwhelmingly above the heads of the faithful gathered on the parvis (like Michelangelo's *Moses* in the original plans for the tomb of Pope Julius II). But, in the technical sense, the figure is only a work in cropped high relief, being devoid of the rear half of the body.

Nanni di Banco, having shrewdly become a far from slavish pupil of his younger colleague, impressed on the *Saint Luke* an air of good-natured challenge, as if Donatello's *David*, having become an adult, bearded and fuller-bodied, had finally taken a seat. Ciuffagni, for his part, presented a figure somewhat taller than the others (a feature that made it even more conspicuous in the comparison between seated figures). With hindsight, we can say this revealed the programme for his whole career, namely to plagiarize Donatello, but through misunderstanding: here the figure is *Saint John* from the neck down, while the head comes from the *Saint Peter* on Orsanmichele.

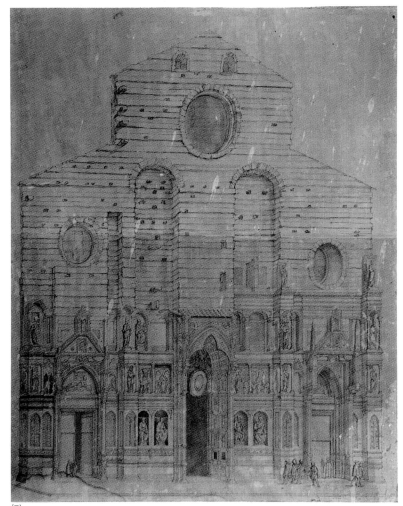

[7]

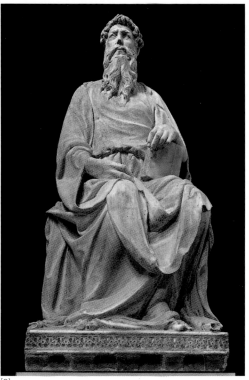

[8]

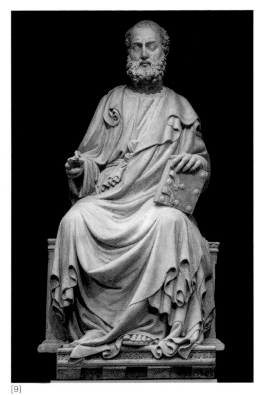

[9]

8.
*Saint John
the Evangelist*,
1408–15, Florence,
Museo dell'Opera di
Santa Maria del Fiore

9.
Niccolò di Pietro
Lamberti, *Saint Mark
the Evangelist*,
1408–15, Florence,
Museo dell'Opera di
Santa Maria del Fiore

ON GIOTTO'S CAMPANILE

Donatello must have begun to rough out the *Saint John* in 1409, and worked seriously on it only after the *Saint Mark* on Orsanmichele, in the two-year period 1413–5, when Nanni di Banco had recently delivered the *Saint Luke*. Lamberti and Ciuffagni, also belatedly, though they (or at least Ciuffagni) had fewer commitments, likewise completed their work in 1415. At that point, the futures of each of the four masters were clear. Nanni di Banco had been called on since 1414 to start work again by himself on the Door of the Mandorla, whose pediment would absorb him in his relations with the Opera until his premature death (1421). The 'Gothic' Lamberti took a wholly different path, leaving Florence permanently for Venice. Ciuffagni and Donatello, incredibly in that order, were involved in beginning work again on the cycle of the *Prophets* on Giotto's campanile, more than seventy years after it had come to a halt half-completed. Andrea and Nino Pisano and their contemporaries had filled only the eight niches on the two main sides, the west side towards the baptistery and the south towards the Signoria. In 1415 work started again from the third completely open side, the one to the east: and until 1422 it dealt only with this. From 1422 to 1436, work went ahead exactly twice as slowly, now on the last side, to the north, made rather less conspicuous by its closeness to the right side of the cathedral.

Although his fame was growing steadily and he was receiving commissions from outside the Opera (Orsanmichele first of all), in these years Donatello remained absolutely constant and straightforward in his behav-

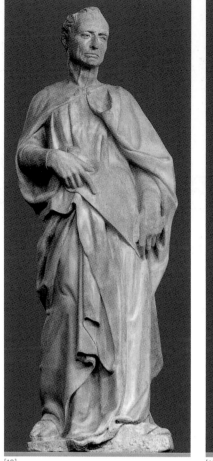

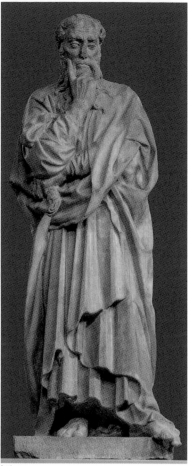

10.
Beardless Prophet,
1415–8, Florence,
Museo dell'Opera
di Santa Maria
del Fiore

11.
Bearded Prophet,
1418–20, Florence,
Museo dell'Opera di
Santa Maria del Fiore

[10]

[11]

iour and commitment towards his principal client. Rather it was difficulties with his colleagues that disturbed the order of events, creating setbacks and changes to the general programme. The reconstruction of events by modern scholars has long suffered from this, even more than is necessary. In the work on the east side the sculptor who caused the disturbance was Ciuffagni. In that on the north side, Ciuffagni was also joined, in a brief but decisive period, by Nanni di Bartolo, a pupil of Donatello's, whom the master had introduced into the work of the Opera at the latest in 1419. Two other factors have complicated the record. The first was the general tendency of the Opera not to assign specific names to the biblical characters, generally recorded in the account books as 'prophets', with the result that some records of payments, read out of context, are misunderstood. The second is that the Opera was simultaneously overseeing, in the campanile and in the cathedral facade, two very similar statuary enterprises, in fact interchangeable in the iconography and dimensions of the figures, but with the clear intention of reserving the finest work that it had managed to get from the artists in each case for the campanile. The series of statues on Giotto's tower was in fact more visible, both because there were only sixteen of them, and because their relationship with the architecture

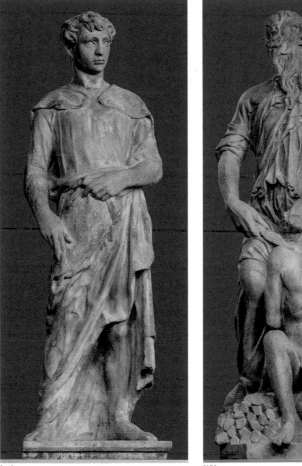

12.
Bernardo Ciuffagni,
Donatello, and
Nanni di Bartolo,
Joshua (Ciuffagni),
transformed into
Saint John the Baptist
(Donatello and Nanni
di Bartolo), 1415–6
and 1420–1, Florence,
Museo dell'Opera di
Santa Maria del Fiore

13.
Donatello and Nanni
di Bartolo, *Abraham
and Isaac*, 1421,
Florence, Museo
dell'Opera di Santa
Maria del Fiore

[12] [13]

was extremely clear; and then eight *Prophets* sufficed to bring the work to an end. In the facade, however, the individual statues ended up being lost within a programme that was too dense and broad, whose outlines and time frame no one could divine. It is significant that, when in the mid-1430s the fourth side of the bell tower was complete, work on the facade actually came to a standstill, resulting in an impasse that lasted a century and a half and was then lamentably resolved by dismantling the whole structure. Anticipating the unifying threads running through its following history, it can be noted that Donatello, symptomatically, never made any statues for the cathedral facade; Ciuffagni, by contrast, had to make every effort to appear beside him in the campanile, but in the end he was forced to accept the decisions of the administrators of the Opera, who, albeit with an obliging delay, sent him back to work for the cathedral.

ON GIOTTO'S CAMPANILE: THE *BEARDLESS PROPHET*,
THE *BEARDED PROPHET*, THE *JOSHUA/JOHN THE BAPTIST*
AND *ABRAHAM*
The first statue for the east side of the bell tower was a *Joshua* assigned to Ciuffagni in 1415. Soon after, in the same year, Donatello was

allocated two *Prophets*, on which he worked in succession in 1415–8 and 1418–20. They are in order, by almost unanimous agreement of scholars, the so-called **Beardless Prophet** and **Bearded Prophet** (figs. 10–1). In the overall invention of the first, the sculptor was still respectful towards the scheme set by Andrea Pisano and the other Trecento masters, with the mature and thoughtful biblical character unrolling a scroll to the crowd from above. But for the first time the figure lost its beard, and displayed a gaunt head, concentrated and sorrowful, inspired without any doubt by the most striking examples of ancient Roman portraiture. In the generous and complex folds of the garment and cloak, Donatello began the revolution in Renaissance drapery, which would soon carry with it whole ranks of admirers (starting from Masaccio in painting and Michelozzo in sculpture): the fabrics, in the intensity of their plastic life, assume an almost psychological and moral value on the same level as the bodies they clothe and the heads that emerge from them. In the following *Bearded Prophet* the master restored the beard of iconographic tradition, but attributed it, as earlier in the *Saint Mark* on Orsanmichele (pp. 58, 59, 63 and 65), to a classical philosopher with a domed forehead and receding hairline, represented in an attitude of profound meditation, in which the scroll is neglected: his left hand conceals it crumpled on the opposite side, while his right arm serves as a prop to support his head bowed in thought.

In 1419 or a little earlier, Donatello must have recommended the young Nanni di Bartolo to the Opera. He seems to have been his first regular pupil, and the Opera entrusted him with a *Prophet*. Nanni delivered it the following year, but after begging the client for permission to replace its head, which proved defective in some way. This *Prophet*, placed in the aedicule on the second level of the left (north) side of the cathedral facade, would become famous in the following centuries when it was erroneously called '*Poggio Bracciolini*', and attracted an attribution to Donatello, so greatly was it indebted to the first two *Prophets* by the master, in particular the beardless figure. Since 1587 it has been in the cathedral, at the beginning of the left aisle.

With Nanni, in 1420, Donatello perhaps tried to form a partnership to produce sculpture, like the one he had entered into years earlier with Brunelleschi. It would explain the collaboration between the two new partners on the two statues then missing to complete the east side of the campanile, together with the *Beardless* and *Bearded Prophet*. As soon as the two masters had finished the *Bearded Prophet* and the '*Poggio Bracciolini*' respectively, they took over Ciuffagni's **Joshua**, which he had stopped work on a few months after receiving the commission (1415–6; fig. 12). The figure, already roughed into forms that combined the marble *David*, the *Saint George* of Orsanmichele (pp. 59–62, 67 and 71) and the *Beardless*

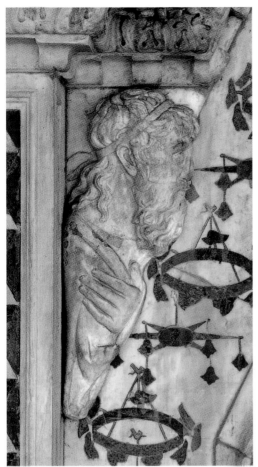

14a–b.
Prophet and Sibyl,
1422

Prophet, had also revealed a problem in the head, which therefore had to be refashioned. In patiently applying himself in partnership to redeem the whole, Donatello alone sculpted this more difficult replacement, worthy of *Saint George* and the other young heroes that he would later produce in marble and bronze, while Nanni worked on the rest of the body. The scroll was finally carved, apparently by Nanni, with an inscription typical of the Baptist ('Ec[c]e Agnus Dei'), transforming the statue into a shaven Precursor, but without garments made from wild animal skins. These details have troubled those modern scholars who fail to reckon with the complicated history of the statue as well as Donatello's constant iconographic waywardness: twenty years later, in the *Saint John the Baptist* for the Martelli family, he would create an adolescent Precursor (pp. 75, 78 and 80).

As soon as the *Joshua/John the Baptist* was completed early in 1421, Donatello and Nanni worked together on the **Abraham** (fig. 13), the only statuary subject on the campanile to take the form of a group of two figures. Already the early Christian sarcophagi suggested the possibility of enclosing in such a compact formula the culminating moment in the life of the patriarch, resolute in the purpose of slaying his son Isaac to please God. But Donatello, who was responsible for the new invention, made it

explode in a violent coiled movement combining the murderous pressure on the innocent and unconscious victim below and the upward twist towards the outside of the niche, where the viewer seems to glimpse the angel descending on Abraham to prevent the sacrifice. Michelangelo treasured this salient torsion, in dialogue with the imaginary angel, eighty years later and embodied it in his *Saint Matthew* intended for the interior of the cathedral (and today in the Galleria dell'Accademia). But the statuary formula of submission, repeated with a new development by Donatello in the *Judith* cast for the Medici (1457–64; pp. 114–7 and 112), was to enjoy an even more extensive reception all through modern sculpture, from Michelangelo himself to Bandinelli, Bernini and Canova.

In September 1422 the Opera, having noted that four statues for the tower, although they had been completed for some time, had not yet been installed, ordered this done. It can therefore be concluded that on the east side of the campanile it was soon possible to admire, from left to right, the *Beardless Prophet*, the *Joshua/John the Baptist*, the *Abraham* and the *Bearded Prophet*. Meanwhile, the Opera had begun work without delay on the last series of statues, on the north side. It started, at the latest in March, with the *Obadiah* by Nanni di Bartolo. He finished the whole sculpture by himself within the year, and instead of adding a biblical verse to the scroll proudly signed it, the first statue on the tower to bear a sculptor's name.

RETURN TO THE DOOR OF THE MANDORLA: THE *PROPHET* AND THE *SIBYL*

For his part, Donatello, acknowledged as the most important sculptor in Florence at least since the *Saint George* was unveiled on Orsanmichele in about 1417, remained at the disposal of the Opera – also because of his established reputation for working rapidly – not only for the campanile. In 1419, together with Nanni di Banco, he had helped Brunelleschi to create a brick model of the incredible dome on which Filippo was staking his reputation. In the winter of 1420, within a few weeks he had carved the *Marzocco* in *macigno* stone to be placed by the Opera on the staircase of the apartment in the convent of Santa Maria Novella, which the Comune had reserved for Pope Martin V and his followers, on the slow journey from Constance to Rome (pp. 70 and 71–2). In 1422, his friend Nanni di Banco had recently died young, and Donatello was asked to complete two corners of the cornice of the *Assumption* in the Door of the Mandorla. We do not know what Nanni had envisaged for these leftover spaces between the triangular pediment and the side pinnacles of the door: certainly not the two wonderful heads of a **Prophet** and a **Sibyl** added by Donatello (fig. 14a–b). While inaugurating the very successful Renaissance genre of profiles in ancient style, with the artist's distinctive assurance, they declare a refusal to submit to the still Gothic and all too symmetrical and decorative manner of Nanni's work.

15.
Jeremiah, 1423–6,
Florence, Museo
dell'Opera di Santa
Maria del Fiore

16.
Habakkuk, 1426 c.–
1427 and 1435–6,
Florence, Museo
dell'Opera di Santa
Maria del Fiore

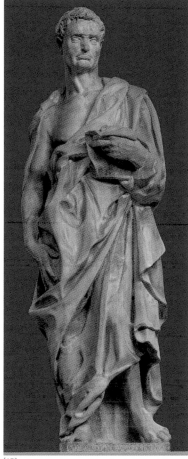

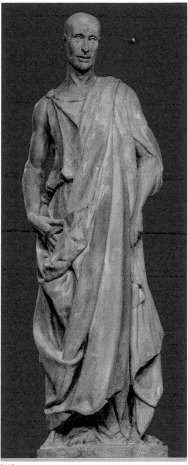

[15] [16]

IN GIOTTO'S CAMPANILE: THE *JEREMIAH* AND THE *HABAKKUK*

The series of four statues for the north side of the campanile had got off to a good start in 1422 with Nanni di Bartolo. The following year he was responsible for the first setback to the work. Though he had secured the commission for a second figure immediately after delivering the *Obadiah*, in 1423 he fled because of his debts to Venice, never to return. The work was transferred to Ciuffagni, who, after much planning and effort, produced the disappointing *Isaiah* in 1427. Meanwhile, between 1423 and 1427, to complete the quartet with all the diligence he was capable of, Donatello sculpted two of the most powerful and striking statues of the century, namely the *Jeremiah* and *Habakkuk*, signed on the bases 'OPVS DONATELLI' (perhaps for the first time in his career). The **Jeremiah** (fig. 15), bundled into his broad, heavy cloak with its endless creases, leaving his right arm and half his chest naked, gazes in absorption at some distant objective and ignores the short scroll that he holds carelessly in his left hand, and on which is carved, barely visible, his name. The **Habakkuk** (fig. 16), the highly applauded '*Zuccone*', with his angular, battered head like that of some noble featherless bird, also reveals his energetic right arm and part of his left, while the rest of his body is swathed in a sweep-

17–8.
Cantoria, 1433–9,
the whole and a
detail, Florence,
Museo dell'Opera di
Santa Maria del Fiore

ing cataract of large folds, and the scroll is now reduced to a small tube that has slipped between his hand and right thigh. The overwhelming reception that both of these *Prophets* had in the painting of Masaccio (who died in 1428), then spreading to the major painters of early fifteenth-century Florence, reveals how excessive are the doubts, which should anyway be borne in mind, by those who wonder whether the *Jeremiah* and the '*Zuccone*' were not made in reverse order. This is because, following the Opera's only accounts relating to Donatello, one discovers that one of the two statues was made between 1423 and 1426, while the other was finally delivered only between 1435 and 1436. Yet in 1427 Michelozzo, then in a new artistic *compagnia* with Donatello, declared to the Cadastral Register that the second figure was three-quarters accomplished.

The long time that elapsed between 1427 and 1435, however, is explained by Ciuffagni's *Isaiah*, which hindered the decisions of the Opera for a long time, due to the dissatisfaction they felt with it. Only when all four statues for the north side had been approved would it have been sensible and economical to install them in their niches, evidently in a single operation, by erecting a single scaffolding. When the *Isaiah* was complete, also in 1427 the Opera commissioned a further figure from Ciuffagni. In 1433 it was given the name of *David* and was finished in 1434. But in the end, in April 1435, the Opera decided that a statue by Ciuffagni, contrary to what he probably hoped, should be added to the cathedral facade instead of the campanile, and that a statue by Donatello should be placed in the campanile. One might wonder, at this point, if there was really no place in the campanile for one of Ciuffagni's two works, since the Opera only had three: the *Obadiah*, *Jeremiah* and *Habakkuk*. But the fact is that as the fourth and last statue on the north side of the tower, the Opera now preferred the so-called *Pathetic Prophet*, sculpted as early as 1422–3 by Giuliano da Poggibonsi for the aedicule on the second level of the south side of the facade of the cathedral, directly opposite the side of the campanile to be filled. That figure, in short, was at hand to be transferred to the tower, where work on the *Prophets* was finally completed by 1436.

THE *CANTORIA*

If Donatello had earlier failed to fulfil his obligations to the Opera, in 1433, on returning from his last and important stay in Rome, he certainly would not have obtained the commission for the so-called **Cantoria** (figs. 17–8), the organ loft intended to be placed above the door of the sacristy on the south side of the cathedral, the sacristy of the Canons. As Brunelleschi's dome advanced towards completion, the period of the great interior furnishings of the cathedral had now arrived. Since 1431–2 Luca della Robbia had received the first prestigious assignment of his

[17]

[18]

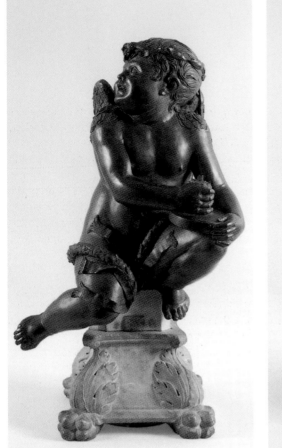

[19] [20]

19–20.
*Two Spiritelli
Candelabra-Holders*,
c. 1436–8,
Paris, Institut de
France, Musée
Jacquemart-André

career, that for the matching *Cantoria*, above the door of the sacristy of the Masses on the north side. According to the order of the works that the Opera had set itself for the presbyteral area of the cathedral, the north sacristy, placed in the privileged place on the liturgical right, was to have preference over the other both in time and possibly in the costs of construction and embellishment. Luca must therefore have secured the assignment for the organ loft on the north side – which had to start its functions well before the other – at a time when Donatello was otherwise occupied, or he may already have gone to Rome. Working at much the same speed, Luca completed his task in 1438, while Donatello finished his in 1439.

The two marble complexes follow the same general scheme, which must have benefited from Brunelleschi's approval, if not his original inspiration. A parallelepiped-shaped enclosure resting on corbels, similar to a segment of the stone gallery inside the cathedral itself, or to a suspended sarcophagus of the kind customary in Tuscan monumental sculpture of the Gothic period, was regenerated in the forms of antiquity, being combined with the memory of some piece of a great Roman temple entablature. On this core of ideas the two sculptors reflected with the utmost

independence and freedom, with results celebrated in all the manuals of art history. Luca produced a gallery not only finely carved and carefully polished, but even more clearly defined in all its parts of imagery and ornament faithful to their vertical and horizontal correspondences. Along the friezes of three lesser entablatures in which the mouldings of a single, ideal giant entablature can be seen, run the verses of the last hymn of the *Psalms* (150); and in the ten panels on two levels enclosed between the three entablatures, pilasters and corbels, festive groups of boys and girls are engaged in an exemplary performance of the verses. Donatello, by contrast, devised a sort of enormous trinket in which the essential horizontal and vertical partitions merge into a supremely dynamic continuum. The movement flows first of all from the wild and ceaseless capering of the *spiritelli*, who seem to be skipping all around the parapet as if it continued, to left and right, beyond the limit of the wall to which it is anchored. But the phantasmagorical effect is heightened by the variety of materials (marble, bronze, coloured stones, fragments, often gilt, of glazed ceramic forming the tiles of the mosaic ground) and, again, by the sketchy character of the carving, studied to be viewed from a distance, within a sacred space that was often sunk in gloom or darkness, or lit by candles.

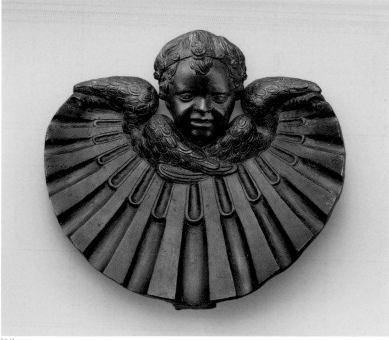

[21]

THE BRONZES FOR THE TWO *CANTORIE*

For both the *Cantorie*, Donatello, who in the meantime had also become the greatest bronze-worker in Florence after his master Ghiberti, prepared two pairs of metal accessories. Luca's *Cantoria*, installed before the other, and admired in its completeness during the solemn rites for the Council to reunite the Churches in the presence of Pope Eugene IV, the Roman Curia and numerous foreign dignitaries (1439), required two candlesticks for the organist. These Donatello conceived, with incomparable inspiration, as two *Spiritelli Candelabra-Holders* glimpsed by the viewer during a pause in their perpetual flight beneath the sky of the dome, perching on the cornice as if on the eaves of a building (figs. 19–20). A few years earlier, in the crowning of the Cavalcanti altar in Santa Croce (pp. 50 and 51), he had devised an equally lively theatre of sprites, but represented as standing on a rooftop and leaning forward embracing each other to avoid vertigo. After dismantling the parapets of the two *Cantorie* in 1688, the two *Spiritelli Candelabra-Holders* were lost sight of. They reappeared only in the nineteenth century in Paris, where they are now in the Musée Jacquemart-André.

Also lost are the two bronze 'heads' that Donatello added to his *Cantoria*, inserting them in the two central mirrors between the shelves below. Scholars century ago thought they could be identified with two bearded and dishevelled male heads, not at all characteristic of Donatello, then in the Museo Nazionale del Bargello; and not without some reason, since for much of the nineteenth century the figurative elements of the two *Cantorie* had been exhibited first in the Galleria degli Uffizi and then in that museum founded in 1865. In 1931 it was decided to unite the marbles and bronzes, which are still together in the Museo dell'Opera. But recently the completely different story of the male heads has been rediscovered, inventoried in Villa Medici in Rome between the late sixteenth and late eighteenth centuries. So a probable candidate to replace one of them, backed by all the possible iconographic, stylistic, technical and dimensional reasons, is a bizarre *Spiritello* in the Metropolitan Museum of Art in New York (fig. 21). Donatello devised it as a 'head', with its breast forming outspread wings that that are also a shell. If the concept and the model are typical of the master, the excessively careful and cold chasing is not. But the *Cantoria*, together with the contemporary *Pulpit of the Holy Girdle* in Prato (pp. 124–9), is among the works by Donatello in which the head of the *bottega* left the greatest scope to his assistants.

CARTOON OF THE STAINED GLASS WINDOW OF THE *CORONATION OF THE VIRGIN*

Before the Opera officially recorded the delivery of the *Habakkuk*, in 1434 it assigned Donatello, in preference to Ghiberti, a new and important task, the cartoon of the **Coronation of the Virgin**, the glass for the

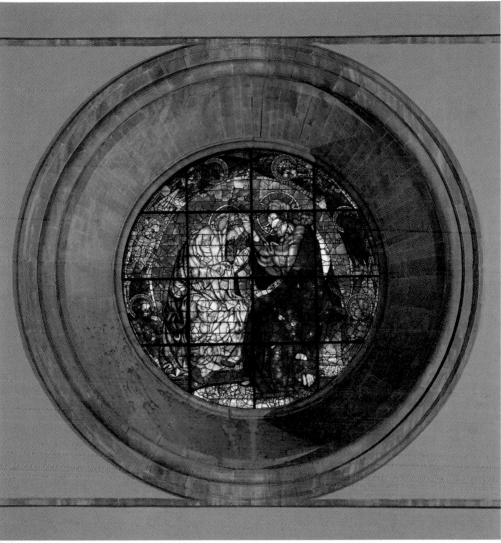

[22]

22.
Donatello (cartoon),
Domenico di
Piero da Pisa and
Angelo di Lippo di
Paolo (execution),
*Coronation
of the Virgin*, 1434–7

main oculus of the cathedral, the one most clearly visible from the entrance to the body of the church (fig. 22). Here the master, as always, paid closest attention to the architectural and spatial context, which was however inversely proportional to his docility to the requirements of the art of glassmaking: quite the opposite, in short, of designers like Ghiberti himself, who was accustomed to working on the service of windows. The divine pair of figures of the *Coronation* stand out against the blue of the artificial (but also natural) sky, enclosed within a glorious circle of red and blue seraphim that prospectively continues the real embrasure of the stone oculus; but the broad, varied, chiaroscuro invention of the garments and cloaks must have caused a great deal of trouble to the master glassmakers (Domenico di Piero da Pisa and Angelo di Lippo di Paolo, 1434–7), accustomed to more minute and detailed drawings, in order to distribute the fragile glass between several pieces. The collabo-

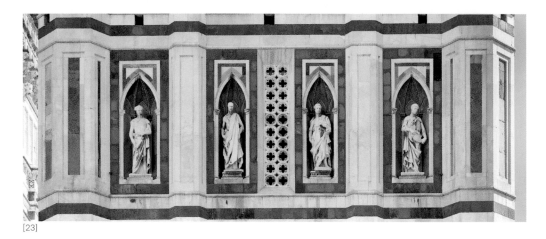

[23]

23.
Florence, Giotto's
campanile,
west side, detail

ration between Donatello and the glassworkers practically revealed that the tradition of polychrome windows was no longer suited to the new Italian architecture.

DONATELLO'S LAST RELATIONS WITH THE CATHEDRAL

The *Coronation* and the marbles and bronzes for the two *Cantorie* were the last works that Donatello made for the Opera. Yet between 1437 and 1439 he received even more demanding commissions, such as the bronze leaves for the doors of the two sacristies, the enclosure of coloured stones that should have contained the octagonal space of the choir of the canons below the dome (according to Brunelleschi's design), and the altars for two of the four secondary radial chapels of the east tribune (of Saint Zenobius), while the other two altars, at least one of them to a model by Donatello himself, was meant to be made by Luca della Robbia. None of this was ever done, and perhaps it was never begun, because Donatello, who in Florence was increasingly attracted to public and private commissions from the Medici, moved to Padua in 1443 or 1444, perhaps to work on some short assignment, but in the end he stayed there for eleven years.

While waiting patiently for him to return, the Opera kept for him at least the commission for the doors of the sacristy of the Canons (while in 1445 it transferred the doors of the sacristy of the Masses to Michelozzo, Luca della Robbia and Maso di Bartolomeo). And it still clung to this hope in 1459, although Donatello, who had returned home in 1454, had left for Siena in 1457. Between these last two dates, in 1456 a passage by the physician Giovanni Chellini of San Miniato, praising Donatello as 'unique and foremost master in making figures of bronze and wood and clay and then firing them', mentions not only the *Joshua* for a spur of the dome of the cathedral, but also a companion piece, 'nine *braccia* high', hence of the same size, which he had 'begun', it would seem recently. We know nothing more: but we do know that in 1463 Agostino di Duccio, a pupil of Donatello in the 1430s, made another 'giant' of terracotta, which was called *Daniel*, and placed on a spur of the east tribune. Agostino, beginning in 1464, would try to make yet another 'giant', but of marble. This was the start of the celebrated adventure of the failed marble colossus

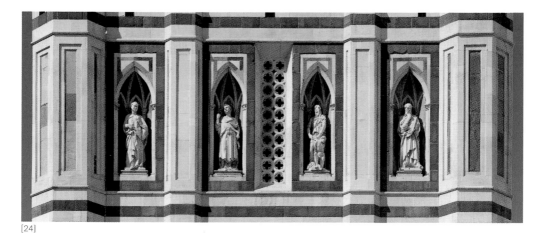

[24]

24.
Florence, Giotto's
campanile, east side,
detail

which the young Michelangelo would turn into the *David* between 1501 and 1504.

What role did the elderly Donatello play in this resumption of the ancient project of the spurs and 'giants'? Thanks to Chellini, we can say it was not small. Anyway, it is certain that in 1464 the Opera del Duomo, grateful to its most illustrious master and the momentous change of style that he had brought about, decided to move the four *Prophets* on the north side of the campanile to the west side (fig. 23), towards the baptistery, and vice versa. On that occasion, the *Habakkuk* and *Jeremiah* curiously ended up on the bases by Andrea Pisano bearing the names of the original statues, namely *David* and *Solomon*. At the same time, since the *Pathetic Prophet* taken from the north side was not by Donatello, a particular exchange had to be made with the *Joshua/John the Baptist* on the east side (fig. 24), especially since the latter, next to the *Beardless Prophet*, must have seemed until that day, in some ways, a copy of it. Whoever transferred the *Joshua/John the Baptist* to the west, near the *Habakkuk* and *Jeremiah* signed 'OPVS DONATELLI', took care, significantly, to affix at the base the apocryphal inscription 'DONATELLO'.

Donatello in Santa Maria del Fiore

Prophet and *Sibyl*, 1422
[14a–b]

Donatello (cartoon), Domenico di Piero da Pisa and Angelo di Lippo di Paolo (execution)
Coronation of the Virgin, 1434–7
[22]

Museo dell'Opera di Santa Maria del Fiore

Francesco Caglioti

The Museo dell'Opera di Santa Maria del Fiore, opened in 1891, and extensively renovated and expanded a few years ago (it was inaugurated in 2015), is now an essential part of the monumental and artistic complex that includes not only the cathedral and Giotto's campanile, but also the baptistery. In fact, the cathedral and baptistery have always, it can be said, functioned in relation to each other, although they were built, governed and maintained throughout much of their past by completely different institutions, especially by the two 'Opere' of Santa Reparata (then Santa Maria del Fiore) and San Giovanni. Moreover, since the latter in 1777 was merged by Grand Duke Pietro Leopoldo of Tuscany with that of Santa Maria del Fiore, the purposes of conservation for which the Museo dell'Opera del Duomo was created in the late nineteenth century were immediately extended to the heritage of the baptistery.

Most of the figurative objects and series now in the museum were added only, and very gradually, after World War II, when the need was felt to rescue the marbles and bronzes exposed to the open air from the action of time and atmospheric pollution. But also works produced for the liturgical experience indoors, such as Donatello's *Mary Magdalene* formerly in the baptistery (pp. 13–5), were finally musealised because of their delicacy. Moreover the collection arose from the need to exhibit two interior furnishings, the *Cantorie* of Donatello and Luca della Robbia (pp. 34–7), removed by various stages from their original locations in the cathedral (1688 and the 1840s) in response to changes of taste. As a result of all these actions, the museum now houses the main core of the works made by Donatello for the baptistery, the cathedral and the campanile, having in this way developed into the largest institution of its kind connected with the artist (an honour that between the nineteenth and twentieth centuries definitely belonged to the Museo Nazionale del Bargello). However, some important works lie outside this core collection.

The baptistery still holds the tomb of Cardinal Baldassare Coscia, the antipope John XXIII, conceived by Donatello, and designed and sculpted by him in partnership with Michelozzo (1422–8), perfectly integrated into the Romanesque architecture (pp. 12–3 and 14).

Some elements were removed from the Door of the Mandorla, on the north side of the exterior of the cathedral, for their protection between the late nineteenth and late twentieth centuries. Some were replaced by copies and others not; but the two profiles of a *Prophet* and a *Sibyl* are still embedded in it (1422; pp. 31 and 32). Inside the cathedral, finally, still in place is the stained glass window with the *Coronation of the Virgin* (1434–7), made to a cartoon by Donatello for the oculus set in the most visible point, the east side of the octagonal drum of the dome (pp. 38–9).

Before making a quick survey of the layout of the museum, in search of sculptures by Donatello that are dealt with in other pages of these itineraries (the baptistery, pp. 12–5, the cathedral, pp. 16–41), it is worth recalling the works by the master that, although commissioned by the Opera del Duomo, have ended up in very different places over the centuries.

The marble *David* was carved in 1408–9 for one of the twelve buttresses or 'spurs' surrounding the space of the future dome. At first it was left unused as too small for that position (pp. 21–3), then it was exhibited from 1416 in the Palazzo della Signoria (p. 114) and is now in the Bargello (pp. 70–1).

The *Marzocco* in *macigno* stone (1420) was assigned by the Opera to Donatello to be set at the foot of the staircase to the apartment of Pope Martin V in the convent of Santa Maria Novella (p. 32). Today it is also in the Bargello (pp. 70 and 71–2).

While the master, working with many assistants, was completing the organ loft, commonly known as the *Cantoria*, over the door of the sacristy of the Canons in the cathedral (1433–9), he was also required to prepare two bronze candlesticks for its companion piece, the *Cantoria* by Luca della Robbia (1431–8), placed over the door of the sacristy of the Masses. These objects, in the form of two *Spiritelli Candelabra-Holders* (c. 1436–8; pp. 36 and 38), must have been dismantled together with the *Cantorie* in 1688. They eventually ended up on the market and reappeared in the nineteenth century in Paris, where they are now in the Musée Jacquemart-André.

Finally, the two bronze 'heads' that Donatello inserted in the two central panels between the corbels of his *Cantoria* (about 1439) were not the two heads of men seen today in those positions, following an intervention of 1931, but very different objects. The *Spiritello* with a breast in the shape of a shell today in the Metropolitan Museum of Art in New York has all the requirements to be one of the two original bronzes (the other is lost; pp. 37 and 38).

The new Museo dell'Opera, based on criteria of maximum clarity of in-

formation, intelligibly organizes, in its arrangement on several floors, the topographical distributions of the area of provenance of the objects. On the ground floor, in the Galleria delle Sculture, visitors will first find, amid the elements from the Door of the Mandorla that have been musealised, the two *Young Prophets* by Donatello and Nanni di Banco (1406 and 1415–20; pp. 19–20) and Donatello's *Vir dolorum* (1408; pp. 20–1). The Sala del Paradiso, also on the ground floor, evokes the open space between the baptistery and the ancient facade of the cathedral on which work began in the late thirteenth century by Arnolfo di Cambio. Here the *Saint John the Evangelist* (1408–15) and his three companions (pp. 25–6 and 27) occupy the two pairs of niches on the first level and at the sides of the main portal in that modern structure that recalls Arnolfo's wall, dismantled in 1587. The order of display corresponds, from left to right, to that documented by ancient sources: the *Saint Matthew* by Bernardo Ciuffagni (1410–5), the *Saint Luke* by Nanni di Banco (1408–13), then the *Saint John* by Donatello, and finally the *Saint Mark* by Niccolò Lamberti (1408–15). Still on the ground floor, the Sala della Maddalena takes its name from the famous wooden statue already mentioned (c. 1440–2).

On the first floor, the Galleria del Campanile exhibits all the marbles removed from Giotto's tower, in particular aligning the panels to the left of those arriving from the main staircase and to the right the statues of *Prophets* and *Sibyls*. The large figures are arranged, starting from the entrance, as if the visitor were walking around the campanile clockwise beginning from the south-west corner. The order is not, however, that desired by the Opera in 1464, when it was decided, clearly in homage to Donatello's merits, to make an exchange between the newest statues on the north side and the older ones on the west (p. 41), but the original order. In this way, four Trecento statues appear to the left of the visitor looking at the whole display frontally (south) and four to the right (west), with in the middle the eight fifteenth-century statues (east and north). Of these eight, four are wholly by Donatello (the *Beardless Prophet*, 1415–8; the *Bearded Prophet*, 1418–20; the *Habakkuk*, 1426 c.–1427, 1435–6; the *Jeremiah*, 1423–6); two by him in collaboration with Nanni di Bartolo (the *Joshua/John the Baptist*, 1420–1, begun by Ciuffagni in 1415–6; the *Abraham and Isaac*, 1421); one by Nanni alone (the *Obadiah*, 1422); and one by Giuliano da Poggibonsi (the so-called *Pathetic Prophet*, 1422–3). However, if we were to retrace the whole history of the fifteenth-century statues year by year, from 1415 to 1436, it would be very likely that in the arrangement before 1464, with a single difference from the way it is presented today in the museum, the *Joshua/John the Baptist* would take the place of the *Pathetic Prophet* and vice versa (pp. 27–32, 33–4 and 41).

In the Sala delle Cantorie, the two organ lofts by Donatello and Luca della Robbia, suspended at a certain height above the heads of visitors,

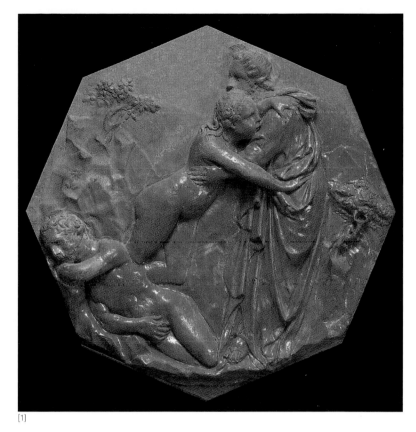

[1]

face each other respectively from the north and south walls (so reversing the original relationship between the cardinal points). In the long period between the first dismantling of the original furnishings in 1688 and their revaluation in the course of the nineteenth century, various structural and decorative items were lost. The result is that in Donatello's *Cantoria* the whole cornice with amphorae and palmettes has been reconstructed in stucco since 1891, and the famous frieze of the *spiritelli* is set a few centimetres lower than the original, while above the dance of the putti there runs one replica fascia too many, with mosaic tiles, the same number of centimetres high. Luca's *Cantoria* has similarly lost, among its structural components, much of the entablature, which was therefore made good by also reconstructing two segments of the cymatium at the ends, in two alternative versions. At the recent reopening of the museum, resin copies of the two *Spiritelli* now in Paris were placed on these, but due to the break in the cymatium in the middle, they are too far apart from each other, as well as inverted in relation to the original arrangement.

Also in the Sala delle Cantorie, finally, is Donatello's only work in the museum that has no connection with the cathedral, the campanile or the baptistery, being intended for domestic and private use. This is the **Creation of Eve** (fig. 1), an octagonal glazed terracotta that was originally enclosed, between two other scenes from Genesis, now lost (the *Creation of Adam* and *Original Sin*?), into the wooden front of a wedding chest. The front of its companion chest, which has survived almost mi-

2.
Donatello
(and a Florentine
cabinetmaker), front
of a cassone with
Stories of Genesis,
c. 1408, London,
Victoria and Albert
Museum

[2]

raculously, is in the Victoria and Albert Museum in London, and the three octagons that complete the cycle (the *Condemnation of Adam and Eve*, the *Expulsion from Paradise*, the *Labours of Adam and Eve*) rest not on one of their sides, but on a point (fig. 2). The two wedding chests were extraordinary examples of Donatello's early work as a coroplast (c. 1408). The addition of the *Creation of Eve* to the museum as a gift when it was founded was perhaps due to a fortunate misunderstanding that associated it with the hexagonal marble tiles by Andrea Pisano for Giotto's campanile, which include a *Creation of Eve*.

Donatello in the Museo dell'Opera di Santa Maria del Fiore

Young Prophet, 1406 (from the Door of the Mandorla in the cathedral)
[fig. 2 on p. 19]

Vir dolorum, 1408 (from the Door of the Mandorla in the cathedral)
[fig. 4 on p. 21]

Creation of Eve, c. 1408
[1]

Saint John the Evangelist, 1408–15 (from the cathedral facade)
[fig. 8 on p. 27]

Beardless Prophet, 1415–8 (from Giotto's campanile)
[fig. 10 on p. 28]

Bearded Prophet, 1418–20 (from Giotto's campanile)
[fig. 11 on p. 28]

Bernardo Ciuffagni, Donatello and Nanni di Bartolo
Joshua (Ciuffagni), transformed into *Saint John the Baptist* (Donatello and Nanni di Bartolo), 1415–6 and 1420–1 (from Giotto's campanile)
[fig. 12 on p. 29]

Donatello and Nanni di Bartolo
Abraham and Isaac, 1421 (from Giotto's campanile)
[fig. 13 on p. 29]

Jeremiah, 1423–6 (from Giotto's campanile)
[fig. 15 on p. 33]

Habakkuk, 1426 c.–1427 and 1435–6 (from Giotto's campanile)
[fig. 16 on p. 33]

Cantoria, 1433–9 (from the cathedral)
[figs. 17–18 on p. 35]

Mary Magdalene, c. 1440–2 (from the baptistery)
[fig. 3 on p. 14]

Santa Croce

Gabriele Fattorini

1.
*Saint Louis
of Toulouse*,
c. 1418–25

Santa Croce is one of the most famous monuments in Florence and Italy. Giovanni Villani records that the church was founded on 3 May 1294 as the permanent home of the Franciscan community, by that time established for several decades in the city. The large building faces the piazza before it with a tripartite cusped facade, which was clad with marble shortly after the middle of the nineteenth century. At that time Santa Croce was a symbol of the newly united Kingdom of Italy, since Ugo Foscolo had sung of it in *Dei sepolcri* (1807) as the pantheon of illustrious Italians, the burial place of figures such as Niccolò Machiavelli, Michelangelo Buonarroti, Galileo Galilei and Vittorio Alfieri.

Before it received its present Neo-Gothic facade, the church had a rough stone front, in which Donatello's **Saint Louis of Toulouse** (fig. 1) stood out above the middle portal. This monumental gilded bronze statue is today preserved in the Refectory of the ancient convent, set in a stucco aedicule that replicates the marble one in which it was originally placed in Orsanmichele (pp. 63 and 64).

After sculpting the *Saint Peter* for the Arte dei Beccai e Pesciaioli (c. 1410–2, with Brunelleschi for the intarsia decoration in the niche; pp. 56–7, 59, 63 and 65), the *Saint Mark* (1411–c. 1413; pp. 58, 59, 63 and 65) for the Arte dei Rigattieri e Linaioli and the *Saint George* (c. 1415–7; pp. 59–62, 67 and 71) for the Arte dei Corazzai e Spadai, Donatello designed the principal tabernacle on Orsanmichele for the Parte Guelfa. It was set at the centre of the facade on Via dei Calzaiuoli, like a sort of ancient marble templet, with a tympanum, fluted pilasters, columns and a round-headed arch. This was in the early 1420s, and the great master had conceived the first Renaissance aedicule in Florence, completing it by 1425 with the *Saint Louis*: a truly surprising debut in bronze, not only by the sense of truth in the features of the young saint of the house of Anjou, but above all by the idea of engulfing the figure in the glittering and

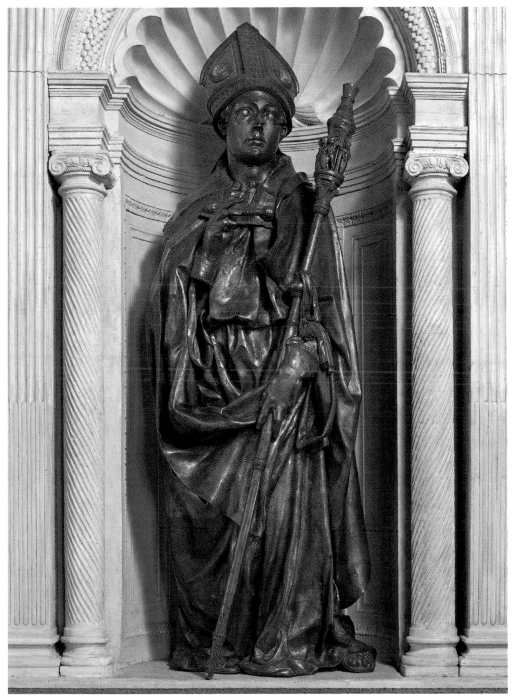

[1]

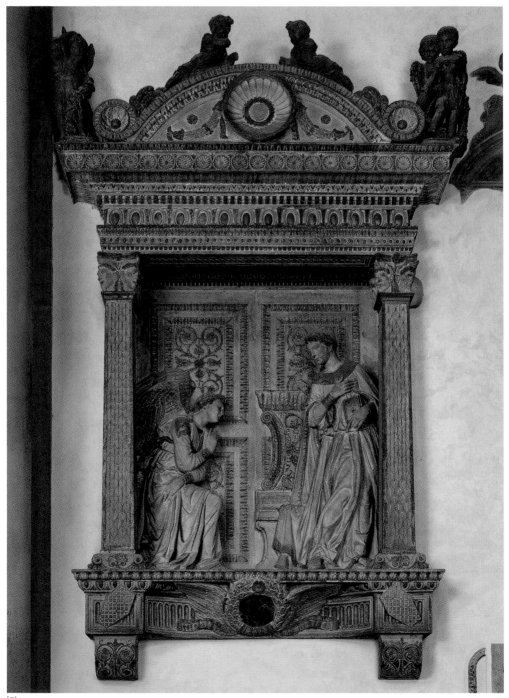

[2]

pictorial swelling of the folds of his large cloak, with a material rendering of the effects of light glancing off the metal, something no one had ever attempted before. In 1463, the Parte Guelfa ceded the tabernacle on Orsanmichele to the Arte della Mercanzia, which filled it with Andrea del Verrocchio's group of the *Doubting of Saint Thomas* (1483). In this way the *Saint Louis*, depicting a venerated Franciscan, was retrieved for the facade of Santa Croce.

Meanwhile, the Gothic interior of the church was enriched by fifteenth-century works of art, notable among them the sepulchral monuments of the chancellors of the Florentine Republic Leonardo Bruni and Carlo Marsuppini, erected in Renaissance forms respectively by Bernardo Rossellino (c. 1450) and Desiderio da Settignano (c. 1459). Not far from the former, towards the end of the right aisle and near the door leading to the cloister, we find Donatello's **Cavalcanti *Annunciation*** (fig. 2). It is an altarpiece in Renaissance format, carved in *macigno* stone and illuminated with gold. On the step appear the coats of arms of the Cavalcanti family that commissioned it, and on the cymatium it has 'six putti holding some festoons, which seem from fear of the height to be clinging to each other for reassurance', as Giorgio Vasari wrote. The close relationship between these *spiritelli* and those dancing in the *Cantoria* made for Santa Maria del Fiore (1433–9; pp. 34–7) makes it clear that Donatello worked on the altarpiece in the mid-1430s, setting within the frame the 'figure of the Virgin, who, alarmed by the unexpected apparition of the Angel, makes a most becoming reverence with a sweet and timid movement of her person, turning with most beautiful grace towards him who is saluting her' (an invention promptly borrowed by Filippo Lippi in the Martelli *Annunciation*, completed in about 1440 for San Lorenzo). Here again are the words of Vasari, who took advantage of this work to develop a memorable description of Donatello's distinctive way of sculpting the drapery so that it adheres to the forms underneath to render the volumes of the bodies, with 'a masterly flow of curves and folds [...] evoking the suggestion of the nude of the figures'.

Vasari, moreover, knew Santa Croce well, because he was long employed in rearranging the interior according to the taste and liturgical needs of the mature sixteenth century, eliminating the partition that divided the space of the congregation from that of the clergy. Next to that partition, on the wall in the left aisle, rose the chapel of the Blessed Gherardo da Villamagna, with at its centre Donatello's famous **Crucifix** (fig. 3), moved in 1571 to the Bardi di Vernio Chapel, at the left end of a transept that is remarkable as a veritable gallery of fourteenth-century Florentine painting by the succession of spaces frescoed by Giotto and his finest pupils.

The polychrome wooden *Crucifix* is notable for the elegance of its

[3]

3.
Crucifix, c. 1408

elongated proportions and the loincloth defined by its curved folds: an elegance in the manner of Lorenzo Ghiberti, which Donatello came to know well, while working in 1404–7 on the North Door of the baptistery. However, this late Gothic spirit contrasts with the accentuated realism of the head, which closely matches the *Vir dolorum* that Donatello sculpted in 1408 for the keystone of the arch of the Door of the Mandorla of the cathedral (now in the Museo dell'Opera; pp. 20–1). Hence the *Crucifix* must have been carved at a similar date. It owes its fame to the anecdote recounted by Vasari, who relates that Filippo Brunelleschi criticised its expressive vigour, accusing his friend Donatello of having 'put a peasant on the cross'. Filippo then carved the *Crucifix* in Santa Maria Novella, and before its harmony Donatello could only exclaim: 'You will be allowed to sculpt Christs and I peasants.'

Donatello in the basilica of Santa Croce

Crucifix, c. 1408
[3]

Cavalcanti Altar, c. 1433–5
[2]

Donatello in the Complesso Monumentale di Santa Croce

Saint Louis of Toulouse, c. 1418–25 (from the *Aedicule of the Parte Guelfa, later the Mercanzia*, in Orsanmichele)
[1]

Orsanmichele

Aldo Galli

The tall Gothic building that looms over the houses in Via dei Cal-zaiuoli, in the heart of Florence, on the street leading from Piazza del Duomo to Piazza della Signoria, is unusual in every respect (fig. 1). Its hybrid appearance, of a church in the form of a civil edifice, is the result of a history in which sacred and profane are inextricably united. The name Orsanmichele, derived from the oratory of San Michele in Orto that stood here already in the ninth century, has been applied ever since to this part of the city, where the wheat and flour market was first held in the thir-teenth century. To better protect the goods and buyers, a loggia was built in 1284 and an image of the Virgin and Child on one of its pillars soon became the object of lively devotion. That first building had a troubled history, being severely damaged by fire in June 1304, then when the Arno flooded disastrously in November 1333. Hence in 1336 the Signoria – the government of the Municipality of Florence – ordered that instead of the old and dilapidated portico a new edifice should be built, larger and more splendid, which we still see today. The ground floor was originally open to the streets around it with ten rounded arches, while the two upper floors – with spacious chambers lit by huge windows – were used as grain and flour warehouses as well as the offices of the magistrates responsible for controlling and supervising the merchandise.

With time the devotion to the Virgin gained even greater sway and the space devoted to prayer came to prevail over that for doing business. This change became particularly marked after the most highly esteemed Florentine artist of the time, Andrea Orcagna, between 1352 and 1359 created a sumptuous marble tabernacle at one corner of the loggia to contain a large panel painting of the *Virgin and Child*. The result was that in about 1370 it was decided to move the market elsewhere, fill in the arches of the loggia and make Orsanmichele a church proper, though the building retained its profound and long-established civil features.

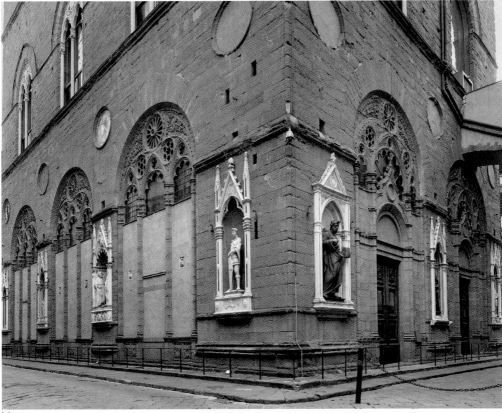

1.
North and west sides

In particular, in 1339 it was laid down that the most authoritative of the city's twenty-one Arti (the guilds that all those who worked independently in Florence were required to join) should place the image of their patron saint on one of the pillars of the loggia. A serious recession set in soon after, beginning with a dire famine, followed by the failure of some of the city's most important banks, political and social upheavals and finally the grievous toll of the great plague of 1348. The upshot was a suspension of the work, which was not resumed with the desired energy even when that grim period ended.

It was only in the early fifteenth century that the plan for the statues of the patron saints was revived. While in the previous sixty years only three of the fourteen niches had been completed, between 1403 and 1425 all the others were added in a lively rivalry between the guilds. The results mark one of the high points in the history of Italian sculpture and the public emergence of that new and eminently Florentine style today known as the Renaissance. The leading sculptors in the enterprise were Niccolò Lamberti (the oldest, who produced two marble statues), Lorenzo Ghiberti (who delivered three bronze statues to the richest and most important guilds, the last one as a replacement for one of the fourteenth-century sculptures), Nanni di Banco (who added three tabernacles, in one case with a group of four figures), and of course Donatello, the only sculptor to receive commissions for four pillars, for a total of three marble statues and one bronze.

Donatello's first work for Orsanmichele should definitely be numbered among the most unfortunate in his catalogue, being still inadequately understood and appreciated: the **Saint Peter** for the Arte dei Beccai e Pesciaioli (fig. 2). Although we have neither the deed commissioning the work nor a record of the payments, an indirect trace suggests it was unveiled in 1412. All the sources, starting from the earliest (Antonio Manetti, c. 1494–7; Francesco Albertini, 1510), agree it is by Donatello. Interesting clarification then comes from an anonymous compilation in the early sixteenth century, known as the *Libro di Antonio Billi*, which states that both the figure of *Saint Peter* and that of *Saint Mark* (made immediately after for the same cycle) were by Donato 'although they were assigned to him together with Filippo di ser Brunellesco'. This information has been fully confirmed by the recent discovery of a document from 1412 that reveals a legal dispute over money between the two artists, who at that time worked in partnership. The statues for Orsanmichele must have been the main reason for their agreement, as well as the ensuing rift.

In spite of so much evidence, critics still find it difficult to assign *Saint Peter* to Donatello, rather attributing it to a modest sculptor such as Bernardo Ciuffagni. Filippo Brunelleschi has also been named with greater justification, though his contribution to the tabernacle of the Beccai is more likely to be found in the perspective intarsia in coloured marble lining the niche. It is certainly thought-provoking to suppose that Brunelleschi may have suggested to his companion the idea of giving the apostle the solemn and severe appearance of a togaed philosopher, but the execution of the statue – the first Italian sculpture no longer in the Gothic manner – must in any case be attributed to Donatello at the age of twenty-five, a first work, and as such betraying some hesitancy. We could say that *Saint Peter* is to Donatello's catalogue as the *Triptych of San Giovenale* is to Masaccio's: a foreshadowing of imminent developments.

A rather surprising aspect of the *Saint Peter* is his pose, curiously turned to the right, so that the apostle seems to address passers-by on the thoroughfare of Via dei Calzaiuoli, ignoring those standing in front of him. It is an attempt, still rather awkward, to endow the figure with movement. The cycle of statues on Orsanmichele, placed in open niches set just above the heads of the viewers, prompted the sculptors to progressively rethink the relation between the statue, the public and the space. It was a crucial nexus, in which Donatello played the leading part and it irreversibly undermined the conception of the frontal figure, immobile, solemnly placed at the centre of a niche that had dominated Florentine sculpture in the fourteenth century, passing without any substantial evolution from Andrea Pisano to Niccolò Lamberti, who sculpted the placid *Saint Luke* for the Arte dei Giudici e Notai between 1403 and 1406. (Ousted two hundred years later by a more modern bronze figure

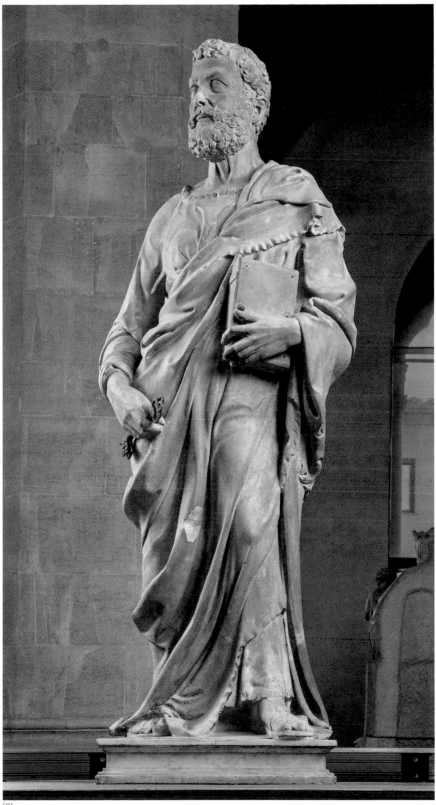

[2]

Orsanmichele

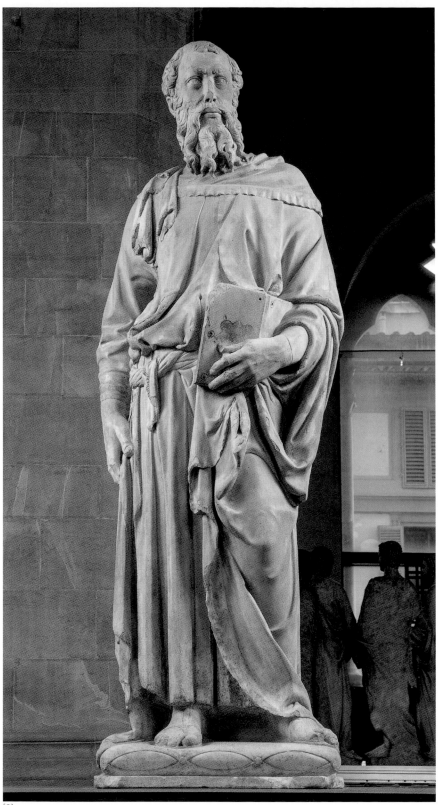

[3]

FLORENCE

by Giambologna, it is now exhibited in the courtyard of the Museo del Bargello.) Even Lorenzo Ghiberti, in the admirable bronze *Saint John the Baptist* for the Arte di Calimàla, the pinnacle of the strand of International Gothic in Florence (c. 1412–6), essentially kept to this scheme, though he was capable of giving his figure a much subtler and more elegant appeal than his colleague.

It was the *Saint Peter* that introduced the idea of the figure in action to Orsanmichele. But the more elementary solution adopted for the patron saint of the Beccai e Pesciaioli was immediately surpassed by Donatello himself with the **Saint Mark** for the tabernacle of the Arte dei Rigattieri e Linaioli (1411–c. 1413; fig. 3). The second work to be commissioned from the Donatello-Brunelleschi partnership, it was in fact sculpted by Donatello alone. Here we pass from the representation of a movement completed to that of a movement as it develops. Standing with easy assurance on a thin pillow serving as a base, the monumental evangelist bends his leg and seems ready to take a step, assuming a pose that is at once firm and dynamic, while with a bold frown he darts his gaze over the heads of the passers-by. The athletic body is not concealed by the garments but emerges forcefully, while the pivoting of his torso articulates in space the figure's plastic energy, heightened by the marked leftward twist of the head. The character of noble authority conferred on the saint was particularly admired by Michelangelo, who saw the 'air of an upright man' (Vasari) in this work by Donatello.

The forceful modernity of the *Saint Mark*, both in conception and execution, is paradoxically heightened by the sharp contrast with the tabernacle housing it, with Donatello and Brunelleschi taking no part in its design. As delicate and precious as lace, it was diligently carved by two specialists, the stonemasons Àlbizzo di Piero and Perfetto di Giovanni, in a very flowery and fretted Gothic style, quite inappropriate to the statue it houses. This incongruous absence of any affinity between sculpture and architecture would only be resolved in Orsanmichele ten years later, once again by Donatello, who designed and executed the radically innovative tabernacle for the *Saint Louis of Toulouse* (see below).

Again fully Gothic, though devoid of any decorative fussiness, is the niche of the **Saint George** for the Arte dei Corazzai e Spadai (c. 1415–7; fig. 4), for which Donatello carved the two bas-reliefs that make up the cusp and the predella, respectively with *God the Father in the Act of Blessing* and *Saint George Slaying the Dragon and Freeing the Princess*. The guild was allotted the least attractive pillar in the whole series, since it incorporated the spiral staircase that – then as now – leads to the upper floors of the building. For this reason, the niche had to be shallower than the others, offering less space to the statue that would occupy it. Donatello drew inspiration from this objective limit to bring out the viv-

*Aedicule of the Arte
dei Corazzai e Spadai,
c. 1415–7, with the
modern copies of
the Saint George and
Saint George Slaying
the Dragon and
Freeing the Princess*

id presence of the warrior, set on the edge of the tabernacle, his foot already eagerly pushing beyond the edge of the base. The result is an almost aggressive relationship with the real space of the street, which must have been even more impressive when the saint brandished the real sword he originally wielded in his right hand over the viewers' heads.

In this young knight Donatello heightened the physical and psychological tension already pervading the *Saint Mark*, while picking up on some of its fundamental features: the oblique twist of the torso and shoulders, the contrast between the right arm outstretched along the body with the left flexed in the foreground, and the concentrated, vigilant gaze turned to one side. Again in this case the figure is striking by its air of boldness, the compressed energy of its pose, and the sense of inner life emanating from it.

The *Saint George*, still one of Donatello's most popular images, has always enjoyed special appreciation. Copied and immediately quoted by sculptors and painters, in the sixteenth century it became an authentic Florentine icon, an emblem of the first, heroic Renaissance season, tirelessly celebrated by writers for its 'soul', its 'pride', its 'vitality' and – in Giorgio Vasari's particularly inspired words – the 'marvellous suggestion of movement within that stone'. This special quality compared to the other sculptures on Orsanmichele meant that as early as the end of the nineteenth century the *Saint George* was replaced with a copy and placed in the Museo del Bargello, where it still dominates the first-floor chamber (figs. 1 on p. 67 and 2 on pp. 68–9). The statue was reunited with the celebrated predella only in 1984, while at Orsanmichele the original *God the Father in the Act of Blessing* still remains on the cusp (fig. 5).

For the first time (at least in a public work) Donatello introduced an idea of revolutionary importance in the predella of *Saint George* (fig. 1 on p. 67). In this case, it was not a matter of bypassing the mediaeval tradition and reverting to classical models, since even in ancient reliefs the background is perceived as an impassable barrier, almost like a wall that forces the figures to protrude into the foreground, to emerge, so to speak, in the space of the viewer. With Donatello, by contrast, the background dissolves and the gaze is now free to probe its depths, at first guided by the foreshortening of the arches and the paving of the palace behind the princess, and then expanding freely across the horizon of tree-lined hills and clouds, barely scored in the marble. Ideas such as these, growing out of the daily practice between Donatello and Brunelleschi, stress with extreme clarity how the Renaissance innovations, even those apparently intended primarily for painters (such as the possibility of representing the third dimension on a plane with effects of illusionistic verisimilitude), were applied in sculpture before painting.

Donatello's work on Orsanmichele, as well as the whole cycle of the

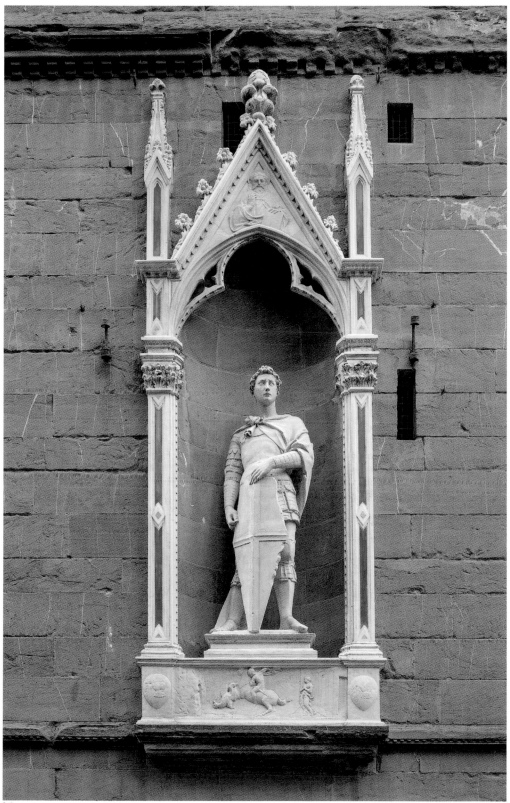

[4]

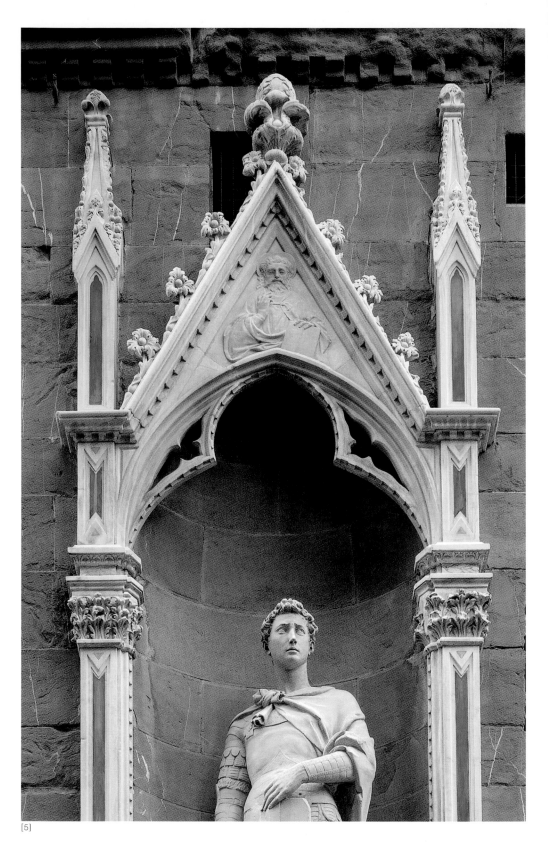

[5]

fourteen tabernacles ranged around the monument, was concluded by the only work commissioned not by one of the guilds but the political organisation for centuries dominant in Florence, the Parte Guelfa. Intended for the most prominent position, at the centre of the east facade, the **aedicule** (fig. 6) was designed by Donatello in drastic and controversial rupture with all those that had preceded it, eliminating any reference to the repertoire of Gothic architecture and devising what could be the elevation of an ancient temple with a triangular pediment, Ionic columns and Corinthian pillars, egg and dentil cornices, with an array of *spiritelli*, mascarons and protomes supporting garlands: a fantastic and irregular archaeology, which goes so far as to insert, between the tabernacle and the corbels supporting it, an astonishing folded mat, with the marble carved to mimic interlacing wickerwork.

At its centre, the *Saint Louis of Toulouse* stood out originally (i.e. from about 1425) in gilded bronze (fig. 1 on p. 49), but shortly after the middle of the century it had to be moved. The Parte Guelfa, its influence steadily declining, had sold the tabernacle and its rights to the Tribunale di Mercanzia, the court responsible for resolving commercial disputes between the guilds. The new owners soon rid themselves of the image of the young Franciscan bishop, who did not represent the court in any way, by presenting it to the friars of the saint's own order in the church of Santa Croce. Here Donatello's bronze was set in a narrow niche above the main portal, where it long remained, barely visible and little regarded. Today it can be admired in the museum installed in the Refectory of the basilica (pp. 48 and 51). As for the tabernacle, since 1483 it has been occupied by the group of the *Doubting of Saint Thomas*, brilliantly inserted by Andrea del Verrocchio.

The originals of *Saint Peter* and *Saint Mark* are preserved today, together with the masterpieces by Ghiberti and Nanni di Banco (as well as Verrocchio and Giambologna), in the museum set up in the great chamber on the first floor of Orsanmichele. To protect the statues from weathering, pollution and the risks of vandalism, a major restoration campaign conducted in the last decades of last century had them removed from the niches, replacing them with extremely faithful casts made using particularly sophisticated techniques. This doubling might have caused misgivings, but it has actually proved extremely instructive. Visitors to Orsanmichele can first make a tour of the outside of the church, viewing the figures set in their tabernacles, at the height and from the point of view that the sculptors had in mind. Then, on entering the museum, they can admire the originals remarkably closely, while reflecting on how the perception of them changes.

Giorgio Vasari recounts that the consuls of the Arte dei Linaioli, who came to examine the *Saint Mark* when it still 'stood on the ground', did

[6]

not in the least approve of the work. The sculptor justified himself by saying that he still had to add some final touches, which would greatly improve it. In reality, having had the statue placed in its niche, he kept it concealed for two weeks without working on it, and finally revealed it to the consuls, now enthusiastic in its praise. It is difficult to tell whether this anecdote says more about Donatello's wit or Vasari's critical intelligence, since he realised clearly how central the observer's viewpoint was to Donatello's aesthetic: it led the sculptor to introduce perspective devices and proportional distortions or leave some parts unfinished – with a disagreeable effect when seen close up – that contributed to the impressiveness of the final effect.

In short, the misgivings of the Arte dei Linaioli can be better understood today by those who observe the *Saint Mark* in the museum, placed very low, where it loses part of that vital impulse and sense of compressed energy that it generates when placed in the niche, at the elevation intended by the sculptor.

Donatello on the exterior of the church of Orsanmichele

Aedicule of the Arte dei Corazzai e Spadai, c. 1415–7
[4]

God the Father in the Act of Blessing (in the tympanum of the *Aedicule of the Arte dei Corazzai e Spadai*), c. 1415–7
[5]

Aedicule of the Parte Guelfa (later the Mercanzia), c. 1420–5
[6]

Donatello in the Museo di Orsanmichele

Saint Peter, c. 1410–2
[2]

Saint Mark, 1411–c. 1413
[3]

Museo Nazionale del Bargello

Francesco Caglioti

1.
Saint George and
*Saint George Slaying
the Dragon and
Freeing the Princess*
(predella), c. 1415–7

The Museo Nazionale del Bargello was founded in 1865 in the ancient Palazzo del Podestà and later of the Bargello with the aim, at first uncertain, and then increasingly clear, of bringing together the finest examples of the 'applied arts' from the Middle Ages onwards. From its earliest years, in addition to this programme, it formed a parallel collection of sculptures, which soon emerged as the most important in the world for the history of Italian art. Nor did this policy prove particularly expensive, because it simply had to draw on the boundless heritage accumulated over the previous three centuries by the Grand Dukes of Tuscany of the houses of Medici and Lorraine, works that were scattered at the time through the Galleria degli Uffizi and other public and private buildings already administered or inhabited by the former crowned heads. Then there was no shortage of artworks from the repeated suppressions of ecclesiastical houses in more recent decades and, to a lesser extent, from donations and acquisitions.

As the fifth centenary of Donatello's birth approached in 1886, the huge Sala dell'Udienza of the Podestà, on the first floor, was the setting for a great exhibition celebrating the master and held the following year. Although the exhibition was largely crowded, here and in other rooms, above all with plaster copies or photos of masterpieces that could not be presented in any other way, as well as examples of the 'applied arts' of the Renaissance in a very generous sense, the chamber, in practice converted into the Salone di Donatello, ended up by becoming the supreme place for seeing the artist's works (fig. 2). Those that can still be admired, documented as by him or attributed to him, or most closely connected to his style, were gradually placed in the Bargello between 1863 (even before it opened) and 1934, forming the largest core of works associated with his name in a museum. A century later, this primacy is rivalled by the Museo dell'Opera di Santa Maria del Fiore,

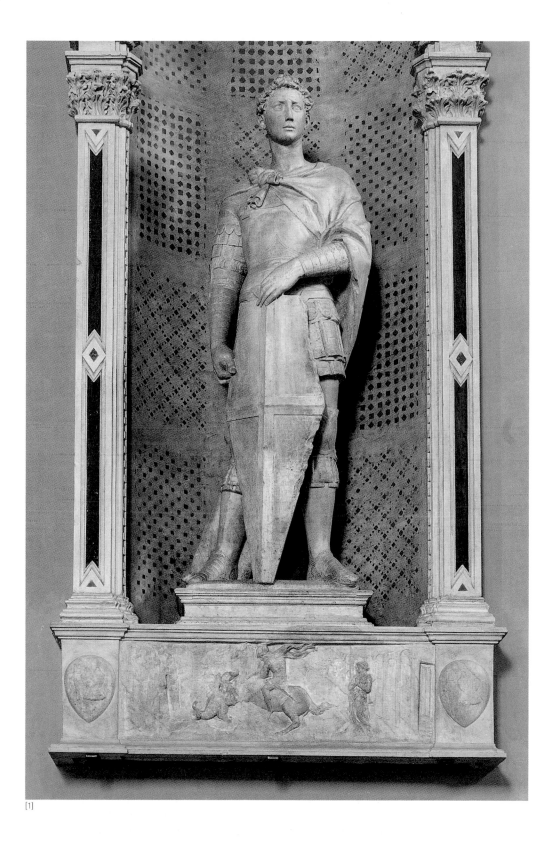

[1]

[2]

2.
Salone di Donatello

where in the same last century works associated with Donatello, gradually removed from the cathedral, Giotto's campanile and the baptistery, have been brought together to protect them from the elements or to remove them from spaces where they were no longer suited for worship (pp. 42–7).

Compared to the Museo del Duomo, whose Donatellian treasures, despite the compelling multiplicity generated by the sculptor's inventiveness, are all due to uniform sources of commission and provenance (with the exception of the *Creation of Eve*, pp. 45–6), the Bargello has the advantage of representing the master's corpus through a more varied sampling of materials, techniques, dimensions, functions and original purposes. Works of a public character alternate with others for private locations. And almost every object has behind it a lively story of survival and transmission through the centuries, further enriching the collection's significance. Finally, in the truly enormous space of the Salone, the Donatellian works in marble, stone, terracotta and bronze

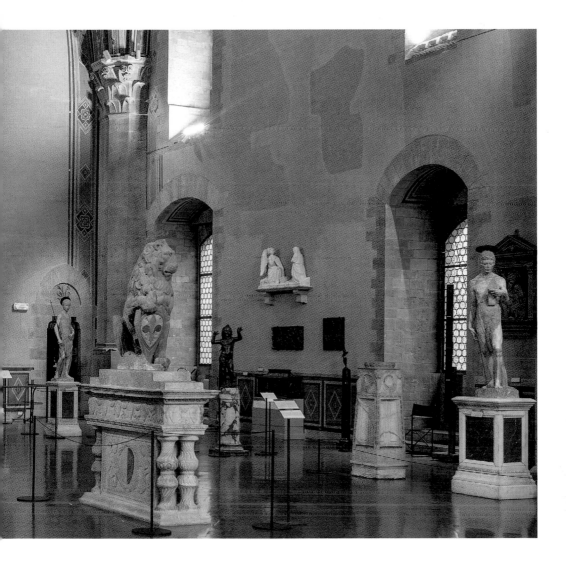

relate closely to a broad and precious collection of sculptures, ranging from Filippo Brunelleschi and Lorenzo Ghiberti to Michele da Firenze, Michelozzo, Luca della Robbia, Agostino di Duccio, Desiderio da Settignano, Mino da Fiesole, Verrocchio, Bertoldo, Vecchietta, Francesco di Giorgio and Pietro Lombardo to the nostalgic Francesco da Sangallo in the sixteenth century. They are a wonderful illustration of the premises and above all the consequences of Donatello's epochal achievement.

The presence of Sangallo, more immediately than others, is a reminder that not all the works, such as his *Saint John the Baptist*, placed here with the guarantee of an attribution to Donatello, have survived the scrutiny of scholars. In addition to Sangallo, it is worth mentioning Desiderio and Bertoldo, two assistants and direct pupils of Donatello in his old age. The first sculpted the *Saint John* in *macigno* stone, a bust in profile (c. 1450–5), which in the nineteenth century was among the most beloved works attributed to Donatello; the terracotta bust of *Niccolò da Uzzano* (c. 1450–5), which from that century until today has

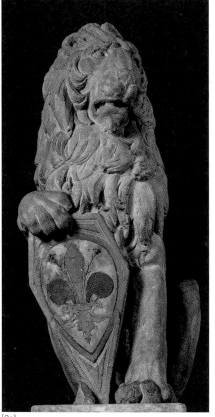

[3a]

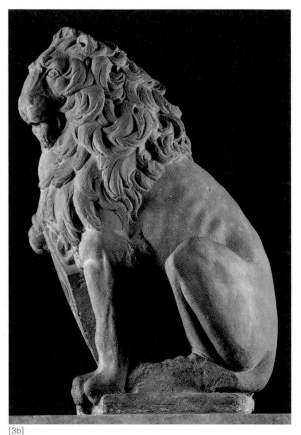

[3b]

often actually occupied a prominent position in the bibliography of the greater master; and the *Coat of Arms of the Martelli Family* (c. 1460), acquired by the State as a work by Donatello as recently as 1996, and still attributed to him in the more belated literature. Bertoldo, for his part, can be credited with the well-known *Platonic Bust* (c. 1470), which also continues to turn up here and there with an attribution to Donatello, as in the past.

Despite these exclusions, the array of autograph works by Donatello remains striking. We will examine them here in chronological order, referring the reader in search of greater depth on two of the most famous (the marble *David* and the *Saint George*) to other sections of these itineraries, where they will be more clearly understood (Santa Maria del Fiore and Orsanmichele, pp. 21–3 and 59–62).

We can start from the *David*, sculpted in 1408–9 for one of the 'spurs' or buttresses of the cathedral around the empty space for the

dome, but installed directly in Palazzo della Signoria (1416; p. 114). In the early seventeenth century it joined the statues in the Galleria degli Uffizi and was moved to the Bargello in 1873. Although its genesis in the two transfers just mentioned should be seen as wholly within Santa Maria del Fiore and its relationship with Palazzo della Signoria, where the statue became an official symbol of the Florentine Republic, it is instructive that in the Bargello it can be seen together with the bronze *David*, made by Donatello thirty years later as a private commission for the Medici. This epitomises in an image the effective takeover of the State by Cosimo the Elder and his brother Lorenzo the Elder.

The *Saint George* in Orsanmichele (c. 1415–7), Donatello's most revered work until the end of the nineteenth century, owes to its fame the fact that it entered the Bargello in 1891–2, alone of the great figures set in the fourteen tabernacles of the Florentine guilds on the exterior of the ground floor of that extraordinary building. Only in recent decades, due to atmospheric pollution, have all the other marble or bronze statues in the tabernacles been moved to the Salone on the first floor of their church-palace, which is now the Museo di Orsanmichele. In all these cases it was a troubled divorce, difficult to resolve, separating the original figures from the original tabernacles on the exterior (where the statues have been replaced with copies). But the case of *Saint George* is more complex, because the Bargello presents the statue and its famous predella in a perfectly cast stucco niche (fig. 1), while on Orsanmichele the whole pillars of the niche and the tympanum with the *God the Father in the Act of Blessing* remain in the original. The spaciousness of the Salone di Donatello means that the complex can be displayed at the centre of the north wall at the end, fortunately almost at the same height as the historical niche.

No less complicated is the stratified display of the **Marzocco** in *macigno* stone (fig. 3a–b). It was sculpted by Donatello to a commission from the Opera del Duomo in the early months of 1420 to watch over the foot of the staircase leading to the apartment designed by Ghiberti in the west wing of the Dominican convent of Santa Maria Novella. Here for many months, from winter 1419 to summer 1420, the Republic of Florence hosted Pope Martin V and his court (p. 32). Elected in 1417 in Constance to put an end to the Western Schism, during his trip to Rome the pope made a stay in Florence that was long enough to allow works such as the *Marzocco* to be made practically before his eyes. Donatello devised the symbolic lion of the Republic for a 'column' whose height is unknown, but it must have exceeded its present base in the museum by a few decimetres. From a higher and narrower position, the lion, with its almost anthropomorphic physiognomy, would have seemed perched and nobly indifferent to the spectators to whom it exhibited, with equal

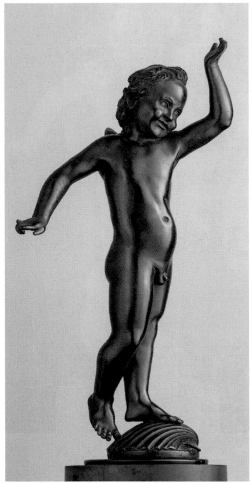

[4a]

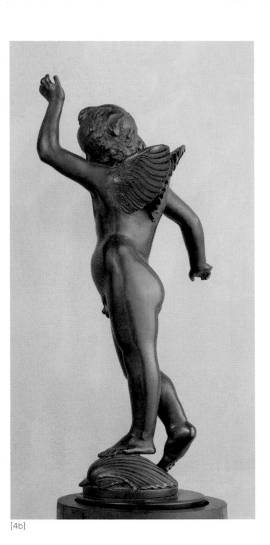

[4b]

4a–b.
Dancing Spiritello,
1429

negligence, the arms of the Florentine Comune (the lily of Tuscan red marble inlaid in white). Between the second half of the fifteenth century and the first half of the nineteenth there is no explicit record of this work. When it was rediscovered in 1812 at the foot of another staircase, on the ground floor of the Uffizi, it was used to replace the *Marzocco* in Piazza della Signoria, a more ancient and by then badly decayed figure, which from c. 1480 had rested, perhaps half-reclining, on an elegant oblong base with double balusters fashioned by Benedetto da Maiano. Already in 1847, however, Donatello's *Marzocco* was sensibly moved to the Uffizi, and from 1865 to the Bargello. Meanwhile, its connection with Benedetto's base, which lasted beyond 1847 with a replacement copy of the lion in the piazza, first of bronze and then stone, meant that in subsequent studies the base acquired a highly acclaimed attribution to Donatello himself. In 1999 the two fifteenth-century originals, created for different places and mounted in different ways, were reunited by moving the base to the Bargello and leaving a copy in the piazza (p. 117).

Changing genre and context completely, the timeline of Donatello's autograph works in the Salone brings us to the very fresh bronze **Danc-**

5.
David Victorious,
c. 1435–40

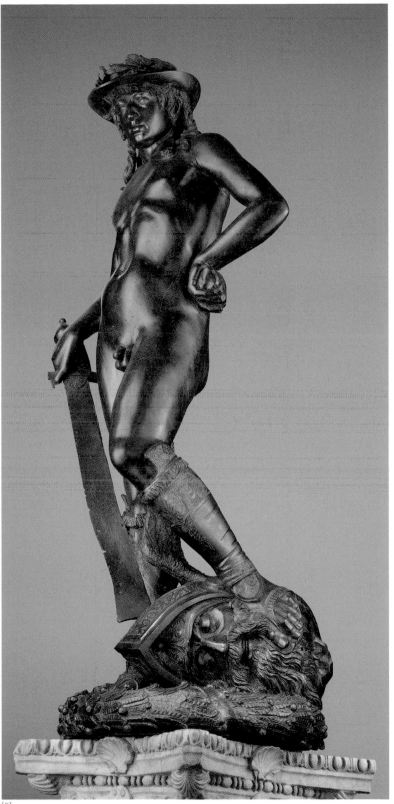

[5]

6a–b.
Attis-Amorino,
c. 1435–40

ing Spiritello (1429; fig. 4a–b), the brother of the *spiritelli* that surmount the holy oil templet at the centre of the baptismal font in Siena (pp. 137 and 139). While one of these little putti left its Sienese location in past centuries and ended up in the Berlin Museums, the specimen in the Bargello must always have remained in Florence. The master discarded it after deciding that beneath the moist seashells at the figures' feet he would insert garlands to convey an even stronger impression of fleetingness. The *Spiritello* in the Bargello, cast without the garland, must have been left in the workshop as a test piece by the master, before being acquired by the Medici and used as a collectible bronze in antique style, the first known to be a fully independent *bronzetto*.

The *Spiritello* provides an apt introduction to the bronze **David** (fig. 5), Donatello's best known work today. Here again, the original high and precarious position was stressed underneath it by placing an unstable object, Goliath's severed head, on an elastic one, the garland. The *David* was cast between about 1435 and 1440 to dominate the principal chamber of the Medici's 'Old House' in Via Larga (now Via Cavour), just north of the palazzo then designed by Michelozzo, where the family moved in

7.
Saint John the Baptist
of Casa Martelli,
c. 1442

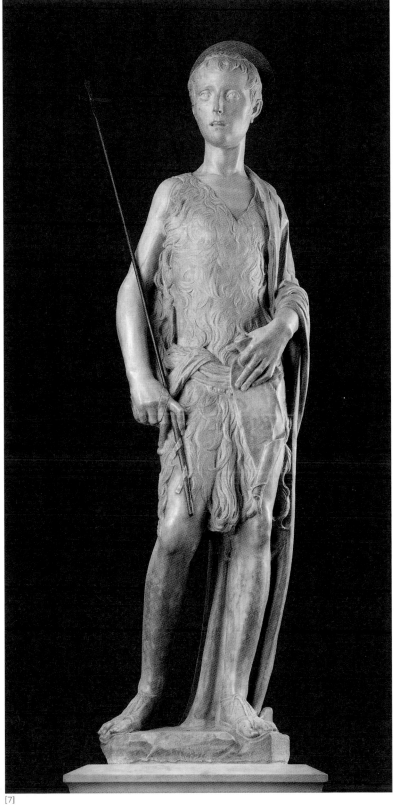

[7]

[8]

the late 1450s taking the statue with them. Some four centuries ago, in one of its many removals in Florence (it was being taken from Palazzo Vecchio to Palazzo Pitti at the time; pp. 114 and 116), it lost its tall base in the form of a column, an indispensable part of the invention. The daring decision to depict the biblical king as a triumphant and bold shepherd boy had already been made thirty years before by Donatello in his marble for the cathedral, transferred to Palazzo della Signoria. The novelty of bronze for such a subject could also be accepted after the last metal statues of patron saints placed by Ghiberti and Donatello in the niches on Orsanmichele (pp. 63, 48–9 and 51). But it was surprising for a work of this sort to now enter a private house at the expense of citizens who were authoritative but not yet acknowledged as the heads of the state. And that the hero was portrayed naked like a pagan idol would have created many problems, though it depicted a sacred figure of the first magnitude, a progenitor of Christ. But the shepherd boy now stood atop a column, just as it had been imagined for centuries that all idols, likewise naked and fashioned in bronze gilt, were exhibited in ancient times. This composition induced the viewer to perceive him as a sort of counter-idol, the result of the rebirth or continuity of a tradition that was here finally exorcised, moralised and Christianised. The authority of this new model was heightened, as in the case of the marble *David*, by its strong civic value, as if it barely mattered that it was no longer proclaimed by the public magistrates but private citizens.

When the Medici took their *David* with them to Michelozzo's palace, they displayed it ostentatiously at the centre of the courtyard. They increased the stability of the column with a large lower support sculpted by Desiderio in the form of four crouching harpies (p. 112), and added a Latin inscription in Sapphic metre in which the hero urged the public to imitate his faith and patriotism. Precariously pouncing on Goliath's head after severing it at a blow, the hero entered into a dialogue with the public without fear of slipping; and from his improvised dais he appeared not only optimistic and proud, but also auspicious in his bodily frame. Since it was musealized, first in the Uffizi (1777) and then the Bargello (1865–6), it has been set too low, in many ways impairing its appearance (become too fragile and irregular) and significance. The time now seems ripe for the museum to redesign its setting to bring it closer to the intentions of the artist and his clients.

One can get an idea of Donatello's extreme originality and unpredictability by looking at the *Attis-Amorino* and the *Saint John the Baptist* of the Martelli family, both just a few steps away from the *David*. These two works are close to the *David* in chronology and area of patronage, because they were placed in the urban residences of patrician families with close ties to the Medici who, following their example, ap-

plied to the same master to obtain other supreme paradigms of sculptural magnificence.

The bronze ***Attis-Amorino*** (c. 1435–40; fig. 6a–b), the first instance of a modern statue in which pagan iconography was given its classical form uncensored and undisguised, is not, however, an example of the faithful archaeological recovery of an antique motif. Humanistic culture, then developing rapidly, was not yet ready for this, at least in figurative practice, and Donatello was still too independent and superior to such a task. Attracted almost instinctively by the possibility of animating the inert essence of the art of sculpture through the irrepressible movements of childhood, the master had found his favoured subject in *spiritelli* already in the early 1420s (on the crook of the pastoral staff of *Saint Louis* on Orsanmichele, pp. 63, 48–9 and 51). Here at the Bargello, the *spiritello* is the absolute protagonist, being charged with a rich variety of attributes wrested from the most diverse antique sources, ranging from the breeches of Attis to the tail of a faun, the talar wings of Mercury, here grafted onto the figure, with typical and fascinating Donatellian ambiguity, without making it clear whether they are part of the body or the sandals. There is enough to baffle any commentator who goes in search of a precise subject. Vasari was the first, seeing the sculpture in the house of the Doni family and calling it a 'Mercury'. Perhaps only one detail can be pointed to that Donatello did not choose wholly at whim, but allowed to be suggested partly by his clients, the series of poppy heads adorning the belt at sides and back. These are emblems of the Bartolini Salimbeni family, in the late 1430s at the height of their fortunes with Lionardo di Bartolomeo, an ally of Cosimo the Elder and the person who commissioned Paolo Uccello to paint the *Battle of San Romano* for his house in what is now Via Monalda. In the same days he may have asked Donatello for the *Attis-Amorino*, which some twenty years later (just like the Medici *David*, transferred to the palace designed by Michelozzo) would be set on a column resting on a foot with four projections (dolphins, not harpies). This plinth, with various emblems of the Bartolini family (including poppies), was the work of an anonymous master close to Antonio Rossellino or Benedetto da Maiano. Today it is in the Victoria and Albert Museum in London. The playful and laughing *Attis-Amorino*, thrown off balance by finding that a serpent has slipped between his feet and into the old sole of one of his sandals, must have conveyed to the Quattrocento viewer a sense of vital energy quite as strong as the *David*.

Donatello depicted the ***Saint John the Baptist* of the Martelli family** again as a figure in movement, but in this case with a delicate, confident step, an adolescent who now seems to be making directly for the desert (fig. 7). Faced with the traditional iconographic alternative

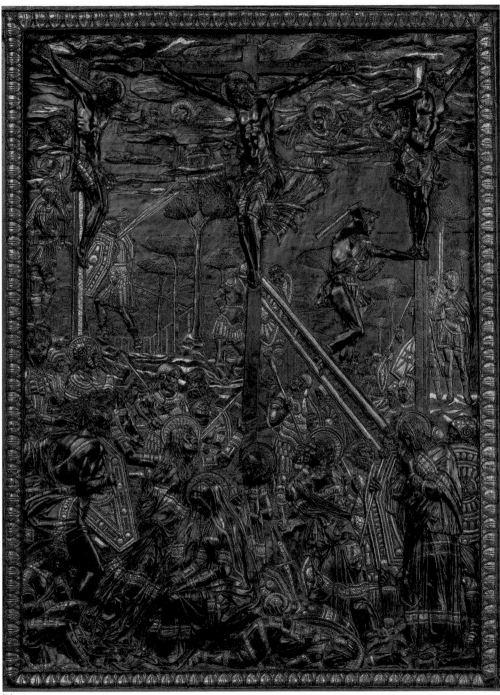

[9]

10-13.
Assistants of
Donatello (to a design
by the master), *Four
Pedestals*, c. 1461–6

between the Precursor of Christ as a wild-looking man in his maturity or an infant, he made an original third choice, adolescence. But he portrayed the saint as already marked by fasting and prophecy, as if the boy full of grace had prematurely taken the world's whole weight on himself. Everything suggests this was Donatello's last marble statue (c. 1442), made just before moving to Padua and turning, because of his age, to modelling wax and clay, so increasing his output of bronzes. For almost half a millennium, *Saint John the Baptist* has had a well-deserved reputation, as a supreme artistic achievement, as an image out of the ordinary of the patron saint dear to the Florentines and repeatedly depicted by them, and as the pride of the family that commissioned it. Like the Medici they placed in their house a symbol of the Republic; and from generation to generation they carefully regulated its hereditary transmission, until it passed to the State in 1913. During the sixteenth century, for the celebrations of the baptisms of babies born into the house of Medici, the Martelli lent the princes their statue, to be placed on top of the ephemeral apparatuses erected in the baptistery. In the twentieth century, the *Saint John the Baptist* was repeatedly misunderstood, post-dated and attributed to Desiderio da Settignano, somehow confusing cause with effect, because Desiderio bore that model continually in mind in his work, as can be seen by comparing it with the *Saint John the Baptist* in *pietra serena*.

The last things wholly by Donatello in the saloon are two bronzes from his maturity.

The first, the **head of a man** with wonderfully ruffled hair, thick eyebrows and beard (c. 1455; fig. 8), perhaps explains most directly what Donatello's contemporaries meant when they celebrated him as the equal of the ancients. This impression seems heightened by the fragmentary character of the head, which, in another way, helps render it enigmatic: perhaps the most enigmatic of the master's works today, since it lacks any connection to a recorded episode in his life. The doubt also remains whether it is the only completed part of a whole figure (like the *Carafa Head* in the Museo Archeologico in Naples, 1456, part of an equestrian group that was soon abandoned), or a fragment specially devised as a rival to the classical world, verging on forgery. Such an attitude is not otherwise proven for Donatello, but not at all alien to his freedom.

The second bronze is the ***Calvary*** (c. 1455–60; fig. 9), transferred to the Medici from the Martelli as early as the sixteenth century. No other metal relief by Donatello was taken to such a degree of finish and ornateness (including gilding and damascening with gilded copper and silver), not even in the four *Miracles of Saint Anthony* on the high altar of the Basilica del Santo in Padua (1446–50), though they represent the highest

[10]

[11]

[12]

[13]

Museo Nazionale del Bargello

step of progress in this direction. This has led to some hesitation in the past in recognising as a fully autograph work a scene finished in every way, in the richness and completeness of the narrative and the clear demarcation of the frame. But the master may have wished to do this as a tribute to the special private destination for which it was made (calling in, however, the help of an assistant for the painstaking metal applications). Nothing is missing, between earth and heaven, in this sacred theatre. Donatello succeeded in embodying in it, on an infinite scale of feelings, poses and gestures, a bewildering choral action to which every presence seems indispensable, from the protagonists to the supernumeraries, from the victims to the executioners, from the most aware or casual bystanders to the busiest or most distracted servants: an admirable sense of the complexity and necessity of the divine plan of the Passion.

In full coherence with Donatello's many-sided activity, not only focused on his own works, but always eager to supply students, collaborators and colleagues with ideas, projects, models and forms, the Salone contains many other pieces that would be inexplicable without him. Next to each other on a stretch of the wall towards Via del Proconsolo are three *Madonnas* for personal devotion, known by the names of their last private owners (Torrigiani, Della Gherardesca, Goretti Miniati). They all stem from his inventions dating from the early 1420s to the mid-1430s, and displaying the infinite resources of his imagination in the genre of domestic *Madonnas*. Each by different hands, they are all very skilful works.

His design and inspiration, but never his chisel, can be read in the four marble pedestals with a pyramidal trunk symmetrically displayed around the central part of the chamber, and which come from San Lorenzo (c. 1461–6; figs. 10–3). Decorated with motifs of woven osiers, shells on festoons, and heads of cherubs at the corners, they are surmounted by garlands similar to that of the *David*, like the torus mouldings of columns, after the example of the much larger storied columns in Rome (of Trajan and Marcus Aurelius). So if the pedestals were made to hold columns, we should think of an unfinished ciborium for the high altar of the Medici church, which could afford a structure like those in the great Roman basilicas (the Lateran, Vatican and Santa Maria Maggiore), because it also performed a liturgy *versus populum*. Alternatively, the four plinths may have been used for bronze candlesticks placed in the chapel of the presbytery or in the crossing, of which we have no other record to date. Be that as it may, these fragments guide the viewer to find in San Lorenzo, with the two pulpits of the Passion and the Resurrection, the last instances of an art and a creative force that was long lived and unfailing to the last, stilled only by death (pp. 103–7).

Donatello in the Museo Nazionale del Bargello

David Victorious, 1408–9, 1416 (from the Galleria degli Uffizi; formerly in Palazzo Vecchio, Sala dei Gigli)
[fig. 5 on p. 22]

Saint George and *Saint George Slaying the Dragon and Freeing the Princess* (predella), c. 1415–7 (from Orsanmichele)
[1]

Marzocco, 1420 (from Piazza delle Signoria; formerly in the pope's apartment in Santa Maria Novella)
[3a–b]

Dancing Spiritello, 1429
[4a–b]

David Victorious, c. 1435–40 (from the Galleria degli Uffizi; formerly in the Medici's 'Old House', Palazzo Medici, Palazzo Vecchio and Palazzo Pitti)
[5]

Attis-Amorino, c. 1435–40
[6a–b]

Saint John the Baptist of Casa Martelli, c. 1442
[7]

Bearded Head, c. 1455
[8]

Calvary, c. 1455–65
[9]

Museo Stefano Bardini

Neville Rowley

The Museo Stefano Bardini is one of the most fascinating places in Florence, reflecting the love of the Middle Ages and early Renaissance that gripped the city in the second half of the nineteenth century. A painter by training, Stefano Bardini (1836–1922) soon became one of the most famous antiquarians in Europe, selling immense quantities of paintings, sculptures and art objects picked up in every part of the Kingdom of Italy, newly founded and in the grip of profound social and economic upheavals. European and American collectors and museums benefited greatly from his depredations. Two of Donatello's most remarkable marble *Madonnas*, the *Pazzi Madonna* and the *Madonna of the Clouds*, are now in Berlin and Boston because they passed through Bardini's expert but unscrupulous hands.

In the gallery of Palazzo Mozzi, the present museum, various versions of the *Virgin and Child* were hung next to each other, like a giant open catalogue for wealthy visitors to make their choice. This arrangement had a profound museographic effect: several museums and collectors transferred it to their walls, from Wilhelm Bode in his Royal Museums in Berlin to Nélie Jacquemart in her Parisian *hôtel particulier*. As for Isabella Stewart Gardner, she wrote directly to Bardini from Boston to obtain the exact recipe for the blue tint of the walls of the Florentine palazzo.

Bardini did not manage to sell all his works abroad. His collection is now owned by the city of Florence, and boasts a number of masterpieces, including two versions of the *Virgin and Child* associated with Donatello. One of them, known as the **Madonna of the Apple**, is certainly an autograph work and dates from the early 1420s. The dynamic pose of the Child and the drapery of the Virgin are treated with sublime virtuosity, a sign of Donatello's absolute mastery of the art of terracotta, little more than a decade after it was rediscovered.

The second version, known as the *Madonna of the Rope-Makers* be-

cause of the application of some lengths of rope to it, appears a masterpiece, despite being very damaged. The composition derives from a small sketch by Donatello, now in Berlin, showing the Virgin seated on a faldstool and venerating the Child cradled before her. Several angels, of which little more than the silhouettes remain, surround the central figures. The work can be dated to Donatello's stay in Siena between 1457 and 1461, when the old sculptor decided to leave his native Florence and settle in the rival city for good. Although he did not directly model the relief made of stucco, leather, shards, glass and pieces of rope, there is no doubt that the challenge of a multi-media work was in keeping with the ideas of Donatello, always a tireless experimentalist.

Donatello in the Museo Stefano Bardini

Virgin and Child, c. 1420–3

Piazza della Repubblica (the former Mercato Vecchio)

Neville Rowley

1.
Circle of Filippo Napoletano, *Piazza di Mercato Vecchio in Florence and the Dovizia by Donatello*, second quarter of the seventeenth century, detail, Florence, Fondazione Cassa di Risparmio di Firenze Collection

2.
Column of *Dovizia* (*Abundance*), with the copy, 1980, of the statue by Giovan Battista Foggini, 1721, replacing that by Donatello, 1429–30

In the 1880s, the Florentines decided to demolish their medieval market, the Mercato Vecchio, and in its place restore the forum from Roman times. Initially called Piazza Vittorio Emanuele II and embellished with an equestrian monument of the king, the restored space was renamed Piazza della Repubblica following World War II and the downfall of the monarchy. The equestrian monument had been moved to the Parco delle Cascine in 1932.

Only in the 1950s was it decided to install, as at the time of the Mercato Vecchio, the column on which stood a personification of *Dovizia* (*Abundance*), a stone statue by Giovan Battista Foggini. In 1721 this sculpture had replaced one with the same subject in *macigno* stone sculpted by Donatello in 1429–30, judged too weather-worn to be preserved in the eighteenth century. The statue that we see today in the piazza is a copy of Foggini's statue, also badly weathered and now kept on the premises of the Fondazione CR Firenze in Via Bufalini.

The importance of Donatello's *Dovizia* can hardly be underestimated. For the first time in centuries, a statue was placed on an ancient granite column, no longer set in a niche. This marked the revival of the columnar monument, which would enjoy a vogue lasting many centuries.

Some fifteenth- and sixteenth-century depictions give us a clear idea of Donatello's lost statue. This vivacious maiden, advancing bearing a cornucopia in one arm and a basket of fruit on her head, would fascinate painters and sculptors for several decades, from Domenico Ghirlandaio to Sandro Botticelli, while the Della Robbia workshop would produce a series of derivative versions in glazed terracotta. When, in the early twentieth century, the celebrated art historian Aby Warburg fell in love with the motif of the 'nymph' through some of these depictions, he was unaware of its origin in Donatello's *Dovizia*.

[1]

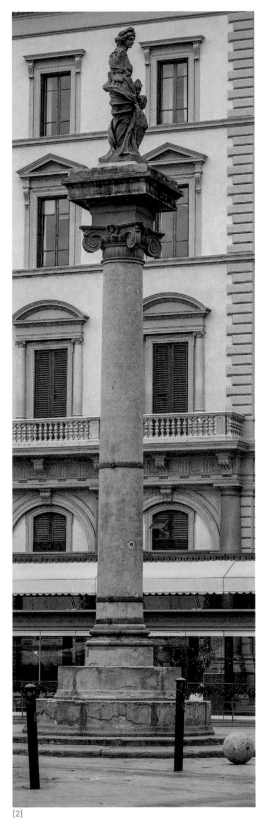

[2]

Piazza della Repubblica (the former Mercato Vecchio)

Santa Trìnita

Neville Rowley

For a few years, the Davanzati Chapel in the Florentine church of Santa Trìnita has been adorned with a **Virgin and Child** in terracotta by Donatello. It is placed on the left-hand wall, above the tomb of Giuliano Davanzati and between two angels frescoed in grisaille. Although it was probably placed here already in the early 1440s, the relief is so damaged that it seems almost out of place in such a setting. For several centuries it was set in the wall of the belltower of the church, placed very high up, giving the sacred image the task of protecting the basilica. Its position may have prevented divine lightning from striking the church, but it had a terrible impact on its state of preservation, the relief having long since lost its original polychromy. Almost the whole lower part of the terracotta was also washed away by the elements. Fortunately, the rest of the relief was protected to some extent by a small lean-to: this allows us to make out the remains of a masterpiece, which can be attributed to Donatello and dated a few years before his departure for Padua.

As in the *Pazzi Màdonna*, now in Berlin, the sculptor sought to bring out the closeness of the Virgin's face to that of the Child: they almost touch, though Christ no longer looks at his mother but at the worshippers, whom he blesses with a gesture of his hand. Behind the main figures, two cherubs are depicted with great virtuosity; the face of the one on the left disappears behind Christ's halo, a motif that may have inspired Michelangelo in his *Pitti Tondo* now in the Bargello.

The *Madonna* of Santa Trìnita is very close to another *Virgin and Child* in polychrome terracotta, well preserved, today in an American private collection. In the years around 1440, the workshop sought to reproduce as far as possible the master's creations, with his active collaboration.

Donatello in Santa Trìnita

Virgin and Child, c. 1435–40

San Lorenzo

Francesco Caglioti

1.
Old Sacristy,
1422–c. 1442

Together with the cathedral of Santa Maria del Fiore (comprising Giotto's campanile) and the basilica of Sant'Antonio in Padua, the basilica of San Lorenzo and its Old Sacristy were the main centres of Donatello's artistic activities. But the works associated with Donatello in the first two locations were overtaken by changes in taste and were extensively altered and impaired as early as the late sixteenth century. The result is that now they are placed in museums or reassembled in their original settings in forms unrelated to the purposes of the master and his clients. The complex of San Lorenzo, however, with systematic farsightedness, has preserved its past display into the present. That said, some apparently minor but in reality decisive changes, which are beyond the eye of even the most attentive visitor, have affected the original project devised by Donatello and his patrons, the Medici. And these are early adaptations, caused by the incomplete state in which the elderly sculptor, dying in 1466, was forced to leave the last part of a too extensive and daring set of liturgical furnishings, consubstantial to the structure, function and purposes of the whole building. The necessity and strength of the ties between these works and the place for which they were made mean that here, more than anywhere else in these itineraries, we need to briefly describe the spatial context.

Founded in late the fourth century just outside the city's Roman walls, San Lorenzo, in the early Middle Ages, was nevertheless the most authoritative church in Florence. It was glorified by having been consecrated by Saint Ambrose, Archbishop of Milan (hence it is sometimes referred to as the 'Ambrosian Basilica') and by preserving the remains of the bishop and patron saint Zenobius. At the start of the following millennium, when the bishops of Florence were firmly established in Santa Reparata (later Santa Maria del Fiore), it was widely believed that San Lorenzo had been the first Florentine cathedral, and that in the meantime it had lost this

[1]

role together with the custody of the relics of Zenobius, also transferred to Santa Reparata. The relationship and even the rivalry between Santa Reparata and San Lorenzo, and between their respective colleges of canons, is an important thread running through the long history not only of the Church, society and culture of Florence, but also the architecture of the two buildings and, finally, the works by Donatello himself in San Lorenzo. These were all commissioned by the Medici, whose patronage Donatello accepted in the mid-1420s, and not just for the work in San Lorenzo, keeping up the relationship, with some intervals, for forty years, until the end of his life.

When Donatello first set foot as an artist in San Lorenzo, the construction of the Old Sacristy (c. 1422–8), founded by Giovanni di Bicci de' Medici as the mausoleum of himself, his wife Piccarda and their descendants, was nearing completion to a project by his friend and in some sense master Filippo Brunelleschi. To the north and east of this completely new structure, the ancient basilica, rebuilt in the eleventh century in Romanesque forms (think of San Miniato al Monte) and then at the centre of an increasingly populous and important parish, was still sturdy and officiated. But for some years the clergy had been discussing the possibility with the wealthiest parishioners of radically rebuilding it. While these plans were the subject of slow and intermittent reflection, Giovanni di Bicci and Brunelleschi gambled extremely boldly but successfully on erecting the new sacristy well in advance at such a distance from the basilica as to condition its reconstruction, not just in the large extension to the west (where the two bodies of the building would sooner or later join) and the proportions of the elevation, but above all in a revolutionary architectural style. Modern studies have long sought to assess just far Brunelleschi was responsible for each part of the famous basilica, which was built with a real and definitive sense of purpose only from 1442, first outside the Romanesque one and then as a replacement for it, with the work brought to an end a few decades after Filippo's death in 1446. But the intimate coherence between the new sacristy and the new basilica shows both that the design of the latter is essentially due to him, and that he had had a clear idea of the plan since the early 1420s.

Inspired almost equally by the models of ancient Rome, pagan and Christian, and the Romanesque revival of sacred architecture in Tuscany in the eleventh-twelfth centuries, Brunelleschi's work in San Lorenzo, and in particular the basilica, derived a very powerful impulse from a liturgical peculiarity of which the perception has gradually been lost, and almost its memory. In all three phases of construction (the early Christian, the Romanesque and the Brunelleschian), San Lorenzo kept the chancel towards the west, unlike most longitudinal churches which

2.
Filippo Brunelleschi,
Donatello
and assistant,
Andrea di Lazzaro
Cavalcanti called
Buggiano, *Tomb
of Giovanni di Bicci
de' Medici and
Piccarda Bueri*,
c. 1429–33

extend along a west-east axis, with the chancel to the east (including Santa Reparata/Santa Maria del Fiore). This means that its basilican plan with the nave and side aisles resting on columns has always been able to boast a lineage that is not just formal but also functional and symbolic from the patriarchal basilicas of Rome (San Giovanni in Laterano, St. Peter's in the Vatican, Santa Maria Maggiore), all likewise perfectly 'occidented' rather than oriented, with the consequence that their liturgy in the direction of light is also *coram populo*. Everything suggests that the great turning point towards Renaissance sacred architecture, that is, modern architecture, made by Brunelleschi in San Lorenzo was especially encouraged by comparison with those paradigms. And this attitude then guided the choice and distribution of the new furnishings, to which Donatello made a decisive contribution in the same spirit, albeit deviating in many choices of detail – with his profound originality – from what Filippo must have envisaged.

The Medici's aspirations were evidently no less ambitious and precocious than their architect's. At a time when they were still private citizens, at least on paper, they came to transform the parish basilica into a family shrine. And after using the Old Sacristy as the burial place of their founder (Giovanni), they centred the whole basilica on the tomb of his principal heir, and second founder of the new San Lorenzo (Cosimo). To the same degree, indeed to a higher degree, as the nearby family palazzo, built from the foundations up roughly in the same years as the basilica (1444–c. 1457), San Lorenzo became the most striking expression of the magnificence of the Medici and the most powerful instrument and mirror, in the monumental sphere, of their political ascent and conquest of the Florentine state. The erection of Michelangelo's New Sacristy in the

[2]

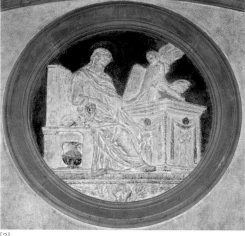

[3]

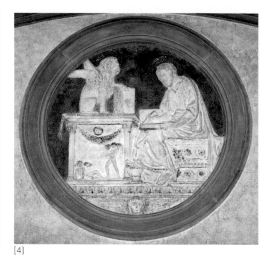

[4]

3.
*Saint Matthew
the Evangelist*,
c. 1435–40

4.
*Saint Mark
the Evangelist*,
c. 1435–40

early sixteenth century and that of the Cappella dei Principi from the end of that same century marked so many stages in the growth of Medici power. And all this was done so systematically, in terms of both topography and planimetry, that the initial step taken by Giovanni di Bicci and Brunelleschi ends up looking almost prophetic in every way.

Fully in accord with the progress of the Medici's commission and works in San Lorenzo, Donatello's presence in this complex can be distinguished as two distinct phases of his long career. Between the late 1420s and early 1440s, initially with Brunelleschi and then on his own, Donatello worked on the sculptures and plastic ornaments of the Old Sacristy. When he returned to Florence from Padua in 1454, he found that the construction of the western part of the basilica (crossing, transept, main chapel and other nearby chapels) was well under way and the prospect of replacing the Romanesque basilica with the new nave was now concrete. In 1456, in particular, the dome over the crossing was closed. Donatello and his assistants worked in the transept and the first bays of the nave from this time on, and more definitely and permanently from 1461, when he returned to Florence for good after spending four years in Siena, begun as an impromptu in 1457. None of Donatello's works for San Lorenzo are directly and specifically attested by records of payment, like all those by Donatello (and many other artists) for the Medici in the fifteenth century; but in San Lorenzo the timeline of the building activity gives us a trace for the figurative tasks.

IN THE SACRISTY

The Old Sacristy (fig. 1), as is well known, brilliantly unites, not just in its functions but also its form, the need to provide a main service space for the clergy of the parochial basilica with the wish to exploit the space as a dynastic sepulchre. In the quadrangular plan of the main chamber, suitable and predictable for a sacristy, a smaller quadrangular room (the *scarsella*) is inserted to the south to host the altar for Eucharistic celebration, mainly required for masses in suffrage of the deceased patrons, buried at the centre of the main chamber. This last culminates in a dome,

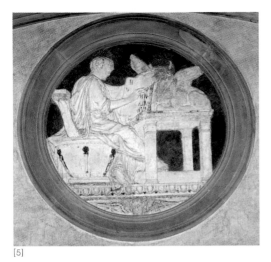

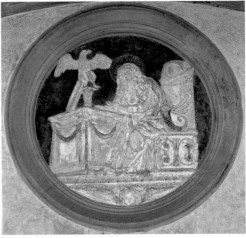

[5]　　　　　　　　　　　　　　　　　[6]

5.
*Saint Luke
the Evangelist*,
c. 1435–40

6.
*Saint John
the Evangelist*,
c. 1435–40

which ends by giving the viewer the impression of a centrally planned temple, a sort of fusion between an ancient imperial mausoleum, a martyr's sanctuary – in particular the rotunda of the Holy Sepulchre in Jerusalem – and a baptistery. Although the consecration of the Medici's foundation to John the Evangelist, patron saint of Giovanni di Bicci, ought to refer strictly to the *scarsella*, it in fact extends to the whole of the sacristy, where it is Saint John who dominates the iconographic choices coordinating the stucco tondi inserted by Donatello in the four pendentives of the dome and at the top of the four large arched perimetric walls.

Donatello's earliest work in the Sacristy must have been the **tomb** of the founder and his wife (c. 1429–33; fig. 2), at the exact centre of the compartment. A well-known monument, it often escapes monographic treatment on him because it is the result of a perfect unity of intents with Brunelleschi, perhaps the culmination of their forty years of professional friendship. Furthering, like the whole sacristy, the twofold public/private and utilitarian/celebratory purpose, the tomb consists of a marble case in the form of a parallelepiped, with a pitched lid, half-hidden beneath a table, also of marble (and bronze), used for laying out the garments in the vestition of the clergy. Although it would be contrived to attempt to exactly divide the responsibilities between the two masters, it is convenient to refer the general project to Filippo and the detailed ornaments to Donatello; and not because the former was only an architect and the second only a sculptor, but because of the features of the work. Inlaid at the centre of the table is a large ancient porphyry wheel that, although by itself sufficing to express the Medici's aims, reveals them if possible even more when it is observed that it has the same diameter as the base of the lantern of the dome above, being set on a perfect vertical axis with it. And there is more: on this same axis, but below the floor, a solitary pillar is found supporting the vaults of the crypt, but also serving as a funerary deposit for the relatives of Giovanni and Piccarda. All this, built as a single whole with the Sacristy, clearly stemmed from Filippo's holistic thinking. Donatello, on the other hand, must have been required to invent the figurative and ornamental apparatus of the sarcophagus, dominated by

[7]

[8]

7.
*Saint John
the Evangelist
in the Cauldron
of Boiling Oil*,
c. 1435–40

8.
*Ascension
of Saint John
the Evangelist*,
c. 1435–40

spiritelli, who hang festoons around all four sides and garlands with coats of arms on the sloping sides of the lid, while supporting the two epitaphs of the deceased on the longer sides. For Giovanni this takes the form of a scroll (as in the tomb of the antipope John XXIII in the baptistery, pp. 12–3) and for Piccarda the form of a tilted *tabula ansata*. In perfect agreement also on the execution, Filippo and Donatello delegated it to their most trusted assistants, so that Andrea di Lazzaro Cavalcanti, known as Buggiano, the former's adopted son, did much of it, while an anonymous sculptor close to Donatello worked on the *spiritelli* displaying Piccarda's epitaph.

So strong was the accord between Brunelleschi and Donatello in the early days of work on the Sacristy, that it is likely to have been the latter who suggested to the former the design of the stone circles at the bases of the two domes in the form of velaria newly rolled up to reveal the 'heavens' above (one of which was visually translated into fresco, with its astronomical and zodiacal properties, in the dome of the *scarsella*). Depicting an elastic element set between an inert support and the supported element pressing on it above was a practice dear to Donatello, in architecture as in statuary. Examples are the osiers in the aedicule of the Parte Guelfa on Orsanmichele (p. 63) and the laurel wreath in the *Pulpit of the Holy Girdle* in Prato (pp. 124–9), as well as the cushions of *Saint Mark* in Orsanmichele (pp. 58, 59, 63 and 65) and the Medici *Judith* (pp. 114–7), or the garlands of the *Spiritelli* on the baptismal font in Siena (pp. 137 and 139) and the Medici *David* (pp. 73, 74 and 77).

In the rest of the Sacristy, Donatello's figurative additions apparently followed each other with increasing independence from Brunelleschi (c.

1435–42). Nevertheless, in the phase of the eight stucco oculi, it seems that the architect still fully endorsed his companion's decisions. The oculi were modelled on the spot, like frescoes, for the first time in many centuries experimenting with parietal stucco in the ancient way. Donatello worked with a skill and ease that justified as perhaps never before his reputation as an inimitable experimenter with the most varied techniques and materials. In the four **Evangelists** (figs. 3–6), with *John* given pride of place over the arch of the *scarsella*, the white of the material is enriched with azurite in the grounds and gold in the haloes and in the ornaments on the garments, seats and desks. Descended from a long medieval tradition that enclosed each in his own study, Donatello's *Evangelists*, regenerated as philosophers of the ancient schools, embody intellectual effort in the most varied poses and attitudes, moving the way they sit, their legs and books with the utmost ease. The presence of the apocalyptic attribute of each, angel or beast, above their desks heightens this impression of everyday life and intimacy, because each attribute assists its master in the work by proffering, browsing or supporting a volume, with a wonderful ambiguity that makes it appear like a part of the furnishings magically brought to life. The viewer ends up unsure whether even the *spiritelli* that emerge from the desks or seats are decorative details of the furniture or supporting actors in each scene.

The technical and iconographic freedom is even greater, if possible, in the four **stories of Saint John**: *The Saint on Patmos, The Saint in the Cauldron of Boiling Oil*, the *Ascension of the Saint*, the *Resurrection of Drusiana* (reading clockwise from the pendentive to the left of the *scarsella*; figs. 7–8). Aware that it would be impossible to compel the faithful to occupy a single position on the pavement from which to look at each tondo with a coordinated perspective, Donatello here indulged his fancy to find a different viewing point, fairly high up and more or less centred, for each scene. And he shaped the dominant elements of the natural and urban landscape (the heights of Patmos and the buildings in the other stories) in a very fine and soft *cocciopesto* over which pass the lively and endless actions of the figures and bystanders with a strikingly modern, almost impressionistic freshness. Each of the three tondi with urban settings was to be a source of decisive developments in Renaissance architecture and painting, from the staircase in the foreground of *Saint John in the Cauldron* (Andrea Mantegna, Domenico del Ghirlandaio) to the chamber in the *Resurrection of Drusiana* (Leon Battista Alberti) and the *sottinsù* of the *Ascension* (Mantegna).

After his work in the upper parts of the Sacristy, Donatello descended along the great arch around the *scarsella*, where two niches with as many full-length pairs of the **Patron Saints of the Medici** in stucco (*Stephen and Lawrence* on the left, *Cosmas and Damian* on the right) surmount two

[9a]

[9b]

9a–b.
Leaves of the *Door of the Martyrs*
c. 1440–2

doors in *macigno* stone with bronze hinges (fig. 1). They open at left onto a compartment for the lavabo and at right onto a storeroom for candles. According to the early account by Antonio Manetti, a passionate biographer of Brunelleschi but in this case reliable, this work led to a perhaps irreparable rift between the two old friends, because Cosimo the Elder, revealing a certain preference for Donatello, allowed him to work on the frames as well as the doors. The sculptor seems to have really acted on his own, without consulting his friend. He introduced into the extremely restrained volume of the chamber two strongly overhung structures, with a larger volume even than their apparent service function. But the exceptional choice of bronze for the hinges reveals how important these doors were to Cosimo: even before entering the small secondary rooms, they provided the Sacristy with the sacred figurative furnishings most in view, and in particular the altar, which, having been conceived by Brunelleschi *versus populum*, could not have a reredos. Then the altar was above all functional to the tomb of the founders of the Sacristy, which, amid *spiritelli*, festoons and coats of arms, displays no conspicuous emblems with a Christian character.

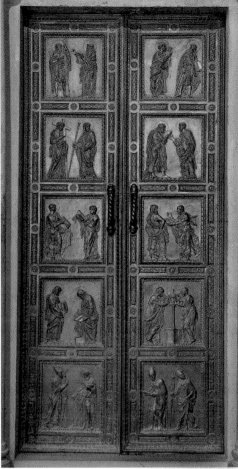

[10a]

[10b]

10a–b.
Leaves of the *Door
of the Apostles*
c. 1440–2

The extent to which Donatello's doors actually fell under the domain of sculpture (Manetti) is revealed by their antiquarian sources, namely Roman sarcophagi, which often have an almost identical feature at the centre of the front, with columns and triangular tympana, alluding to the passage of death. From here Donatello, with his typical assurance and always happy to subvert the scale, roles and internal relationships of the classical models, drew inspiration for true doors, in which the leaves are framed in a similar way.

Pressed by the Medici to seek the noblest possible references for these metal doors, which for the first time were financed by private individuals and in the service of a semi-private setting, Donatello looked at doors in imperial and papal Rome and other eminent places, such as Monte Cassino or Saint Mark's in Venice, finding on some of them panels occupied by standing figures, single or in pairs. The repetitiveness of the motif was an incentive to unleash his imagination as never before, because ten pairs of saints in the panels of the ***Door of the Martyrs*** on the left (fig. 9a–b) and as many apostles, evangelists and fathers of the Church in the panels of the ***Door of the Apostles*** on the right (fig. 10a–b)

[11]

11.
Donatello
and workshop,
then later Andrea del
Verrocchio, *Lavabo*,
1440s and c. 1460

immediately aroused the public's uneasy admiration for figures who variously discourse, dispute, almost clash, attract, distract and ignore each other. The immense variety of movements, embodied in a rough material glowing in unexpected ways, weakened the artist's iconographic precision, so that he only bothered to identify a few of the individual saints by their attributes.

When Donatello went to Padua at some time in 1443 or 1444, remaining until 1454, just as he broke off many works in the cathedral (p. 40), so he must have abandoned some things in the Sacristy. The fanciful **lavabo** in ancient style behind the *Door of the Martyrs* has a boat-shaped basin supported by harpies, from which rises a cup and a vertiginously metamorphic lid (fig. 11). It looks like the early manifesto of a sophisticated ornamental taste that Donatello gave to the virtuosos of intaglio of the coming Florentine generations (Desiderio da Settignano, Mino da Fiesole, Antonio Rossellino, Benedetto da Maiano, Andrea del Verrocchio). Work on the lavabo, broken off shortly before Padua and resumed shortly afterwards, was affected by this double distended time frame and the cultural turn attained in the meantime by the master. The contradictory attributions between Donatello, Rossellino and Verrocchio in early literary sources reflect this sequence of events.

A work by Donatello, completely finished but prematurely lost, must have been the tomb of Lorenzo il Vecchio. He died early in 1440 and was laid to rest, according to the sources, in a double-sided urn which at that date could only have been placed in the great arch between the Sacristy and the adjacent chapel of Saints Cosmas and Damian, erected by Brunelleschi together with it. This location also explains its early destruction, recorded in about 1470, when Lorenzo and Giuliano 'the Magnificents', sons and heirs of Piero il Gottoso, decided to honour their father and uncle Giovanni with the famous tomb, also double-sided, by Verrocchio (finished in 1472). To make way for it they removed their great-uncle, whose descendants had now given up the Medici patronage of San Lorenzo.

IN THE BASILICA

The same web of spatial, iconographic, liturgical and symbolic relations between the sacristy, the altar in the *scarsella*, the tomb of Giovanni and Piccarda and the bronze doors was meant to be embodied on a multiplied scale in the crossing of the basilica: that is, in fact, in the whole basilica, which a shrewd and very well-informed observer in the sixteenth century, Paolo Giovio (later buried in the cloister of the canons of San Lorenzo), considered in its entirety the mausoleum of Cosimo the Elder. Cosimo's tomb is placed, in the strict sense, inside a massive solitary pillar that supports the vaults below the crossing,

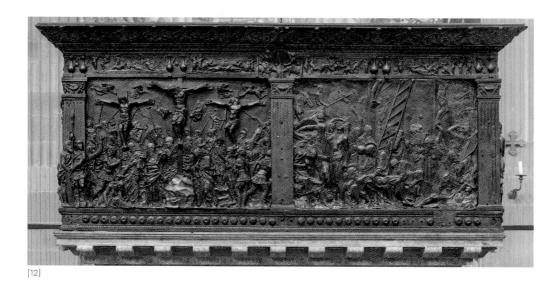

[12]

12.
Donatello
(with Bartolomeo
Bellano and Bertoldo
di Giovanni), *Pulpit
of the Passion*,
c. 1461–6, front

and that emerges at the centre of the crossing itself in the seemingly humble form of a centrally patterned floor slab. Above the crossing, however, rises a dome, just as in the Sacristy above the vestment table concealing the sarcophagus of Giovanni and Piccarda; and a dome was no part of the structural features of the basilicas of Rome, that is the main models of the nave of San Lorenzo, all of which have flat ceilings or trusses. Its insertion in the transept of San Lorenzo appears to be inspired rather by more advanced solemn public models such as the cathedral of Pisa, and it betrays every intention here of creating an absolutely extraordinary funerary monument. The high altar, originally facing the nave due to the perfect 'occidented' position of the basilica, was thus placed, as a first result, in the service of the tomb. And to make this relationship clear to worshippers from their first entrance from the facade into the whole sacred space, the new San Lorenzo never had a choir at the middle of the nave, since Cosimo the Elder and Brunelleschi moved it behind the altar and opened up for it a chapel as broad as the whole crossing.

The external parts of Cosimo's tomb were built only after his death in 1464, and were the work of Verrocchio, probably being completed in 1467, when Cosimo was laid in his pillar. This has long made it difficult, and still does, to understand that the plan for Cosimo's centrally placed sepulchre was made much earlier, and is the origin of today's basilica. Yet it is well known that as early as 1442 Cosimo had formally agreed with the clergy of San Lorenzo that he should be the exclusive builder of the crossing and its adjacent spaces, together with a prohibition on any of

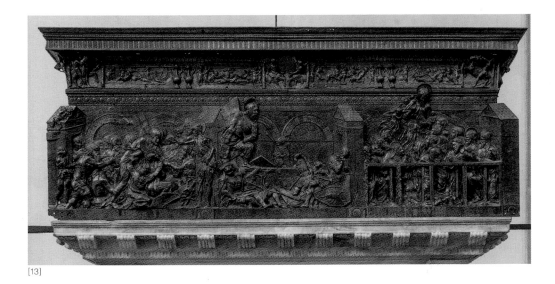

[13]

13.
Donatello
(with Bartolomeo
Bellano and Bertoldo
di Giovanni), *Pulpit
of the Resurrection*,
c. 1461–6, front

the inhabitants of the parish being buried in the basilica. For them the crypt would be available, which consequently, and quite exceptionally, is as large as the basilica itself: the Medici and Brunelleschi had begun it in the 1420s, when they built the first two chambers beneath the Sacristy and the chapel of Saints Cosmas and Damian.

Cosimo's tomb, in other words, was the pivot around which Brunelleschi's basilica developed, just as the tomb of his father and mother was the pivot of the Sacristy. Even the geometric conception of his floor slab, both sharply defined and extremely complex, with a perfect symbolic representation of the cosmos (Cosimo's own name) inscribed within a Greek cross, must somehow derive from Brunelleschi, although Verrocchio was later perfectly capable of performing the work.

All this seems to be taking the reader away from Donatello, but it actually concerns him closely, and explains the two bronze pulpits, otherwise incomprehensible, apart from the disquieting beauty of the individual scenes adorning the parapets, which, like the *Stories of Saint John the Evangelist* in the Sacristy, are a breath-taking crescendo of iconographic and perspective inventions and exceptions.

Early sources tell us that the pulpit to the left of the faithful, namely to the south, which from its five scenes eventually took the name of the **Pulpit of the Passion** (*Garden of Gethsemane, Christ before Pilate and Caiaphas, Calvary, Lamentation over the Dead Christ, Entombment*), was intended for the reading of the Gospel (figs. 12 and 14), while the one to the right, on the north side, called the **Pulpit of the Resurrection** (*Three Marys at the Tomb, Descent into Limbo, Resurrection, Ascension, Pen-*

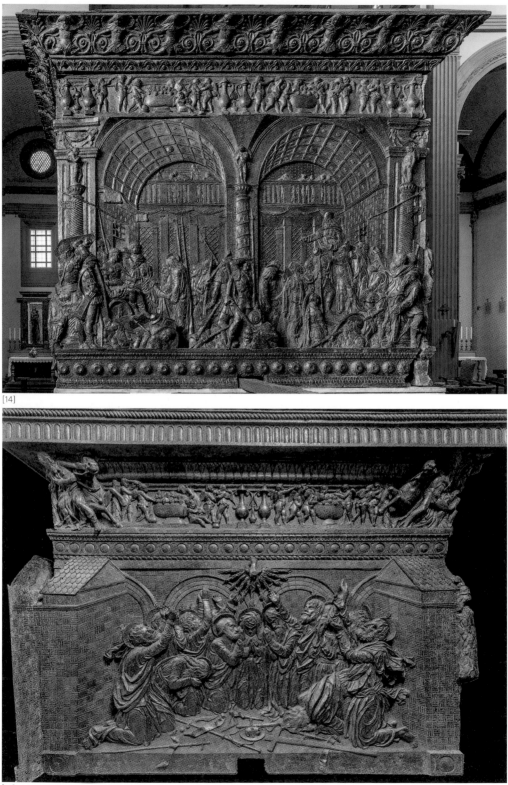

[14]

[15]

tecost, *Martyrdom of Saint Lawrence*), was for the Epistle (figs. 13 and 15). The initiative of these twin works appears extraordinary for many reasons: first of all because in Italy no bronze pulpits existed within living memory, but only ones in white and sometimes coloured marble. In addition, in Tuscan churches a single pulpit was customary, set to the left or right of the congregation depending on whether the chancel jutted to west or east, to enable the reader to face the aisle towards the north, raising the word of God towards the darkness. By contrast, there were two pulpits in the basilicas of Rome, often made by the same craftsmen, and coordinated in style, but of different dimensions, plans and forms, to show that the Gospel pulpit was of greater importance than that of the Epistle. From this tradition Donatello and the Medici even took their decision to vary the dimensions and decorations of the two pulpits, which are not in fact perfect twins; but the typical contrast in the Roman basilicas was attenuated because, combining their example with the Tuscan Romanesque models (exactly as happened in the architecture by Brunelleschi, who associated Tuscany with Rome), for San Lorenzo two parallelepiped-shaped boxes were chosen. This was not just a tribute to local custom, but to better serve the completely new setting that the two Laurentian pulpits would have in the sacred space. In Rome, the coordination between the different volumes of the two pulpits was mediated by the enclosure for the choir in the nave, to which the pulpits were attached. In Florence, when the choir disappeared into the nave, and reappeared in the chapel behind the altar, the two pulpits could only be put in the pillars giving access to that space, placing the high altar in the middle, just as the bronze doors in the Sacristy put the altar of the *scarsella* in the middle. If Brunelleschi's basilica modified the volume of the Roman ones by adding the system of the domed crossing, the two pulpits of Roman origin were required to adapt to this change in their position and reciprocal relationship; because now they would have appeared to the congregation not with their short sides, as they do today, but with their main fronts. In brief, they would have been perfect figurative complements of the high altar, lacking a reredos, and the tomb, without Christian imagery. And their frontal presentation would have allowed them to be read as a continuous narrative, from left to right and from first to second, now no longer possible (fig. 16).

Donatello worked intensely on the pulpits in the last five years of his life, helped above all by Bartolomeo Bellano and Bertoldo di Giovanni. The established custom in his *bottega* of working metals cold after casting, not so much to finish the skin, as was done elsewhere, but to continue to define the forms themselves, meant that his two assistants have left indelible signs of themselves in the episodes: Bellano especially in the *Garden of Gethsemane*, *Calvary* and *Pentecost*; Bertoldo

less strongly but perhaps even more extensively. When Donatello died, however, those two pupils were unable to take the work further, and the two bronze cases remained as we still see them, but in some annex of the basilica: the pulpit of the Passion already assembled, that of the Resurrection not yet.

Half a century later, for the Florentine visit of Pope Leo X, the son of Lorenzo the Magnificent (1515–6), the basilica of his ancestors served as a papal chapel. On this occasion the pulpits were put in place: not, however, for their original function, but as supports for the singers, at the entrance to a temporarily furnished and enlarged presbytery, which reached all the way to the arch to the nave. So here, close to the two pillars of the crossing towards the facade, they were erected end on, distorting them in a way that has lasted until now. This arrangement became established in 1559 and in 1565, when Duke Cosimo I had the bronze cases placed on their present polychrome marble columns (close to the manner of Francesco da Sangallo). Shortly before 1634, finally, the pulpits were moved a little, just enough to free them from the pillars and isolate them, enclosing them at the back for a width of two thirds, already corresponding to the connection to the pillar and the landing of the steps, with modest wooden panels copied from Ghiberti and Giambologna.

Donatello's commitment to the crossing of the basilica did not stop at the pulpits, but had at least three other extensions.

Four bronze *Evangelists* must have been set at the two extremities of the transept, in the niches flanking the arches giving access to the chapels. Remaining at the stage of terracotta or stucco models (the sources are ambiguous), they were put in their final places, where they could be seen until the eighteenth or early nineteenth century. Because of the size of the niches (much higher than they were deep), they must have been more like high reliefs than statues in the strict sense.

In the penultimate bay of the left aisle, above the door leading into the cloister of the canons, one can still see the marble organ loft (fig. 17), which Donatello adorned with polychrome inlays, in the antiquarian taste of the *Cantoria* of Santa Maria del Fiore (pp. 34–7), entrusting the work to one or two anonymous assistants.

Finally, four very original marble bases today in the Bargello (pp. 81 and 82), also in antique style and likewise delegated to assistants, must have supported as many bronze candlesticks, or the columns of a ciborium for the high altar, which through a similar completion would have revealed its whole genealogy from the Roman basilicas. But Donatello's death brought this project to a sudden end, in the same way as the pulpits and the *Evangelists*. Such fertile abnegation, enduring to the last, was lost with him.

In the Martelli Chapel, the first in the left arm of the transept, today

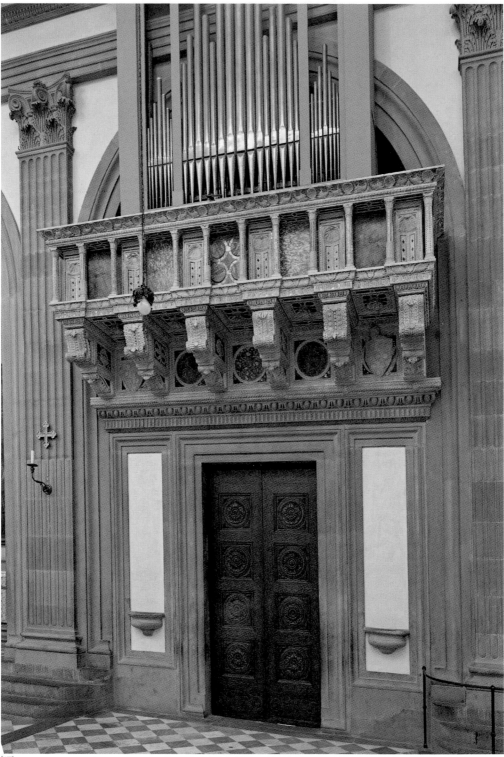

we can admire a family sarcophagus in the form of a marble basket, with bronze and red marble inserts, brought from the bay in the crypt below. This too is a striking invention of Donatello's executed by collaborators.

Donatello in San Lorenzo

Filippo Brunelleschi, Donatello and assistant,
Andrea di Lazzaro Cavalcanti called Buggiano
Tomb of Giovanni di Bicci de' Medici and Piccarda Bueri, c. 1429–33
[2]

Evangelists, c. 1435–40
[3–6]

Stories of Saint John the Evangelist, c. 1435–40
[7–8]

Patron Saints of the Medici, c. 1435–40
[1]

Door of the Martyrs and *Door of the Apostles*, c. 1440–2
[1, 9a–b, 10a–b]

Donatello and workshop, then later Andrea del Verrocchio
Lavabo, 1440s and c. 1460
[11]

Donatello (with Bartolomeo Bellano and Bertoldo di Giovanni)
Pulpit of the Passion and *Pulpit of the Resurrection*, c. 1461–6
[12–5]

Palazzo Medici (later Riccardi)

Francesco Caglioti

Like Palazzo Pitti and Palazzo Strozzi, but before either, Palazzo Medici in Via Larga (later Via Cavour) is the most illustrious example of residential architecture of the early Florentine Renaissance. Like the Pitti, and unlike the Strozzi, this status was heightened and distorted in the following centuries: they were extensively enlarged according to the same original modules, which had nevertheless been conceived as imposing masses, though not as outsize as they later became.

Today in Palazzo Medici, transformed after the family that built it sold it to the Riccardi family (1659), the very regular porticoes devised by the original architect, Michelozzo (1444–c. 1457), coexist in the courtyard with exuberant baroque ornaments affixed by the new owners to the walls and doors (fig. 1). And the walled garden of Cosimo the Elder, the founder of the building, has an unrecognisable appearance, though it still largely retains its past dimensions.

Michelozzo's architecture formed a single whole with a varied array of classical and modern sculptures in marble, stucco, bronze, granite, porphyry and other rare stones, which began to be stripped from it in 1495, a year after the heirs of Lorenzo the Magnificent were sent into exile. Of all this today only the twelve marble tondi remain, the work of Bertoldo di Giovanni, set in the high frieze of the courtyard between the arches and the *piano nobile* (see below). Three on each facade, in the centre they bear the Medici arms in four different guises, and at the sides eight scenes more or less faithfully transposed from antiquity: in seven cases taken from gems, and in one from the flank of a sarcophagus that in the fifteenth century stood outside the baptistery (and is now in the Museo dell'Opera di Santa Maria del Fiore).

Giorgio Vasari attributed to Donatello the initial direction of the whole sculptural scheme in the Medici courtyard and garden (c. 1457–75). His account, which for centuries could not be precisely verified in the setting

[1]

[2]

Palazzo Medici (later Riccardi)

he described, has in our day regained ever greater credibility through numerous rediscoveries of works, fragments and documents.

Donatello had in fact prepared for the undertaking long before it was embodied in the palace. Twenty years earlier, he had created the bronze *David* today in the Bargello (pp. 73, 74 and 77) for the principal chamber of the Medici's 'Old House' not far to the north on the same street. When Cosimo the Elder and his sons Piero and Giovanni moved into Michelozzo's building, a mass that boldly fused the medieval and public model of the Palazzo della Signoria with many ideas gained from the Roman Forums, the *David* was erected in the middle of the courtyard (c. 1459; fig. 2), and the coloured stone column that had always supported it was set on a new marble base with four crouching harpies, carved by Desiderio da Settignano (fig. 3). Of this sophisticated assemblage, inspired by the great imperial candelabra of ancient Rome, only fragments of two harpies survive (Siena, Palazzo Chigi Saracini; Florence, Museo Horne), because the *David*, taken to the Signoria in 1495 (pp. 114 and 116), lost its pedestal a century after, or slightly later, in the move to Palazzo Pitti.

On the other hand, the conceptually similar pedestal of the *Judith* remains almost intact in the Palazzo della Signoria, beneath its statuary group (pp. 114–7). The female counterpart of the *David*, in both her heroic deeds and their symbolic value for Florentine republican freedom, of which the Medici declared themselves the champions, the figure was expressly created to triumph in the garden of their new palace (1457–64).

When Donatello completed it, he was too old to work the stone, and too busy in Siena (1457–61) and later, at the request of the Medici themselves, in San Lorenzo (1461–6), to be able to set his hand directly to the other furnishings of the palace. For these reasons he was assisted not only by faithful pupils such as Bartolomeo Bellano and Bertoldo di Giovanni, but also by other young sculptors who, having grown up in Florence in the years when he was in Padua and northern Italy (1443–54), were ready to support his projects: Desiderio, as mentioned above, Mino da Fiesole, Antonio Rossellino with Benedetto da Maiano, and finally Verrocchio, a pupil of both Desiderio and Donatello.

Bellano and Bertoldo contributed to the bronze prism of the *Judith* (1461 c.–1464), as well as, in the same days, to the two pulpits in San Lorenzo (pp. 103–7). But Bertoldo also carved the tondi in the courtyard (c. 1461–5; fig. 4). Rossellino and Maiano worked on the fountain in the centre of the garden (today in the Pitti, Scalone del Moro). This was the first example of a type with superimposed concentric pools, suggested, like the bases of the *David* and *Judith*, by monumental Roman candelabra, which eventually proved immensely popular. Mino and Verrocchio restored two ancient statues, adding the missing parts, and placing them by the door leading from the garden to Via de' Ginori. The first was

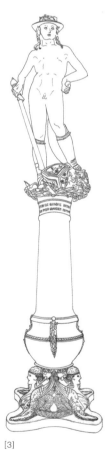

[3]

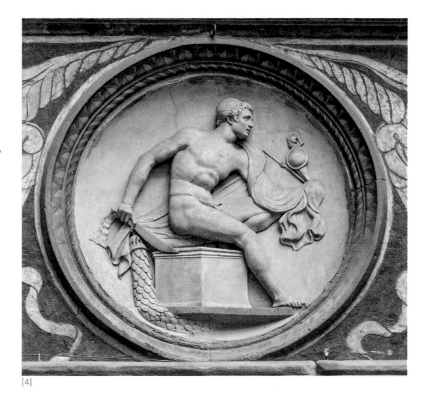

4.
Bertoldo di Giovanni,
*Diomedes and the
Palladium*, c. 1461–5

[4]

Marsyas hung up to be flayed (called the '*Red Marsyas*' in the Uffizi), and the second, now lost, a *Marsyas* flayed and huddled towards the ground, perhaps developed from a different original subject. Before the *Marsyas*, Verrocchio had also mounted various ancient heads above the doors in the courtyard, set in fanciful stucco oculi in the form of rings set with diamonds (Medici emblems) flanked by wings.

Among other restored ancient sculptures, spolia reliefs, and a second granite fountain attributed in early sources to Donatello himself, there must have been the bronze horse's head known as the *Medici-Riccardi Head*, today in the Museo Archeologico Nazionale in Florence. Donatello had measured himself with it since 1456, on a colossal scale, in fashioning the *Carafa Head* (Museo Archeologico Nazionale in Naples), the first section of an equestrian monument for the triumphal arch of Alfonso the Magnanimous king of Naples at the entrance to his palace in Castel Nuovo. The work never went beyond this first piece.

Although dismantled early, the first sculptural furnishings from Via Larga (partly renewed by the Medici after their return in 1512) would become normative through the centuries. Thanks to the removal of the *David* and the *Judith* to the Signoria, the square at the centre of the government of Florence would continue to be filled with statues until the nineteenth century. And the aristocratic buildings of the early modern age would find their prototype of magnificence, not only architectural but also figurative, in Palazzo Medici.

Piazza della Signoria and Palazzo Vecchio

Francesco Caglioti

1.
Copy of *Judith*,
1988

2.
Judith, 1457–64

There is no record of Donatello ever receiving an important commission for the seat of the Florentine Signoria, the centre of government of the Republic, to which he must always have been proud to belong as a citizen. But the outstanding political significance of many of his figures has meant that four of them were eventually exhibited in these spaces (outdoors and indoors), remaining there for periods that were longer or shorter but in any case decisive. Two figures, the *Davids* in marble and bronze, were then moved elsewhere, leaving their mark on the Signoria in documents and chronicles, but above all in the influence they exerted on other works in the same place. The *Judith*, however, is still there, in both the original version and a recent copy. And the *Marzocco* is only present as a copy.

The first figure to arrive was the marble *David*, commissioned in 1408 by the Opera di Santa Maria del Fiore for one of the 'spurs' (or buttresses) of the cathedral around the immense void over which the dome was to be built (pp. 21–3). Too small for such an elevated position, in 1409, on being delivered, it was kept for a position closer at hand, which would also be more prestigious and symbolic. In 1416 the Signoria took it over for the first chamber in the apartment of the gonfalonier and the priors, on the second floor of the palace. There the *David*, accompanied by a Latin epigraph extolling its civic purpose, triumphed for some two centuries as the only statue in the furnishings. It was then moved to the Galleria degli Uffizi and the Museo Nazionale del Bargello (pp. 70–1). Its transit was crucial to the chamber in Palazzo della Signoria, which from the late fifteenth century became today's Sala dei Gigli, its north wall frescoed with *Florentine Patron Saints, Marzocchi and Heroes of the Roman Republic* (Domenico del Ghirlandaio), and spangled with golden lilies on a blue field on the other walls, with an expansion of the heraldic and decorative embellishments that since 1416 had formed the backdrop to the *David*, resting on two corbels.

In autumn 1495, a year after the exile of the Medici heirs of Cosimo the

[1]

[2]

Piazza della Signoria and Palazzo Vecchio

Elder and Lorenzo the Magnificent, the new Republican Signoria, over which Girolamo Savonarola exercised a powerful ideological ascendancy, confiscated the bronze *David* in the courtyard and the bronze *Judith* in the garden of Palazzo Medici, together with their tall bases (pp. 110–2). It had them erected in its seat of power, emblematically, in a way recalling their original locations. The *David* was perfect for the courtyard, where it remained for about a century, though not continuously. Shortly after its arrival, since its nakedness must have disturbed many people's moral scruples, at the top of its base was preferred Verrocchio's 'chaste' *David*, brought down from the second floor of the building, while Donatello's bronze took the place of its counterpart or was hidden in a warehouse. By 1510 the two *David*s had returned to their original pedestals. This suggests that the death of Savonarola in 1498 and the new presence of Michelangelo's *David* in the piazza since 1504, completely naked, had banished the misgivings of 1495. In 1554–5 Donatello's *David* and its base were replaced by the present porphyry fountain (1555–7), made by Francesco Ferrucci del Tadda to a design by Giorgio Vasari to support Verrocchio's *Putto with a Dolphin*, recently brought from the Medici villa at Careggi. This exchange was not meant to censor the *David*, temporarily placed a little later in the niche today containing the *Samson* by Pierino da Vinci (about 1550). It was a promotion, with a view to moving it to the centre of the new and larger courtyard behind the mediaeval palace, by this time the ducal residence. Before 1638, however, the statue ended up in Palazzo Pitti, the main ornament of the mantle of a fireplace in what is now the Sala Bianca. In 1777 it was transferred to the Uffizi for the first time as a museum piece, and this decision marked its destiny until it was moved to the Bargello (1865–6), and therefore until now (pp. 73, 74 and 77).

In 1495, since the Signoria did not have a garden, the **Judith** was put in the piazza, to the left of the staircase towards the main portal, where it formed a corner with the Ringhiera, a broad raised platform for major public events. In 1504 the heroine paid for her lesser dignity as a woman with the promotion of Michelangelo's *David* and passed under the right-hand arch of the Loggia della Signoria. Here from 1554 Benvenuto Cellini's *Perseus* (indebted to both its female companion and the bronze *David*) served as a pendant piece under the left-hand arch. But when Giambologna's *Rape of a Sabine Woman* was completed in 1582 – another statuary group celebrating a male feat – the *Judith* was placed under the side arch of the Loggia towards the Uffizi, and remained there until World War I. After the war, to allude to its first location in the square, it was decided to place it in front of the building's facade, where the Ringhiera had stood until 1812. Between 1980 and 1988, to protect it from the elements, the *Judith* and its whole base were replaced by a copy (fig. 1), and the original complex, restored, was significantly reassembled in the Sala dei Gigli (fig. 2).

Donatello and the Medici would not have devised the *Judith* if they had

not already created the *David*. When the latter, cast around 1435–40 for the Medici's 'Old House' in Via Larga (today Via Cavour), was moved after some twenty years to the middle of the courtyard of their new building nearby (pp. 110–2), the presence of a garden beyond the courtyard suggested the idea of an *alter ego* for it in that space. To double the David's civic message of the *David*, the banner of Florentine republican freedom of which the Medici had become the patrons and defenders, they needed a biblical character who was the protagonist of a similar adventure. This was the first and perhaps the last time in art history that Judith was given the role of an isolated monumental figure, indeed a statuary group, since to vary the formula of the victorious *David* standing over a severed head Donatello staged the subjugation of Holofernes as it was happening, as he had done earlier in the *Abraham and Isaac* on Giotto's campanile (pp. 29 and 31–2). Behind this choice there were centuries of 'psychomachias', allegorical depictions of Christian virtues in the guise of women triumphing over vices represented as male figures. As suggested by an inscription in Latin verse that accompanied the bronze when it was unveiled (1464), Judith and her victim represented the two moral struggles between sobriety and lust and between humility and pride; but a second prose inscription giving the name of Piero il Gottoso, the son of Cosimo the Elder, as the donor, added a dedication to the Florentines' freedom and republican fortitude. Matching the *David*, the *Judith* was also a columnar monument; and its 'column', inspired by the great imperial candelabra of ancient Rome, is the marble and granite one that can still be seen, culminating in the triangular bronze prism of the bed of Holofernes, adorned with scenes of *spiritelli* engaged in the grape harvest and getting drunk, so evoking the inebriation of the Assyrian general. In 1495, however, the confiscation made a change of detail that was far from insignificant, because the two Medici inscriptions were sacrificed to the current brief one, as if the *Judith* had been only then made at the behest of the citizenry.

On the site of the Ringhiera in the piazza, a copy also recalls the *Marzocco* in *macigno* stone, today in the Bargello (pp. 70 and 71–2). But the original by Donatello (1420) was in the Signoria only between 1812 and 1847, having been carved for a completely different and much more reserved public space: the pope's apartment in Santa Maria Novella. In 1812 it took the place of an older *Marzocco*, now badly worn by time, inheriting its base, the work of Benedetto da Maiano around 1480, also today in the Bargello and replaced in the piazza by a replica.

Donatello in Palazzo Vecchio

Judith, 1457–64 (from Piazza della Signoria; formerly in the garden of Palazzo Medici)
[2]

TUSCANY

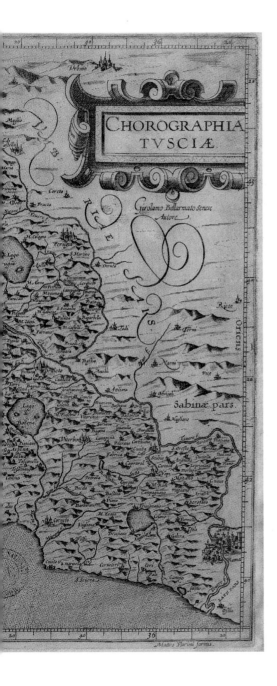

PONTORME

A San Martino

PRATO

B Museo di Palazzo Pretorio

G Cathedral
and Museo dell'Opera del Duomo

PISA

C Museo Nazionale di San Matteo

SIENA

D Baptistery

H Cathedral
and Museo dell'Opera della Metropolitana

AREZZO

E Cathedral

TORRITA DI SIENA

F Sante Flora e Lucilla

PONTORME
San Martino

Neville Rowley

Because of its location in a small church not far from Empoli, this work has long been neglected by scholars, though today there is general agreement that it is a masterpiece by Donatello. It has very close affinities with the great *David* in marble now at the Museo Nazionale del Bargello (pp. 21–3 and 70–1), sculpted for Florence Cathedral between 1408 and 1409, and with the *Saint Peter* created early in the following decade for the niche of the Arte dei Beccai e Pesciaioli on the exterior of the church of Orsanmichele (pp. 56–7, 59, 63 and 65).

The **Madonna** of Pontorme must be understood as a true transposition of the *Saint Peter* into a different technique. The drapery is no longer reminiscent of the curves and counter-curves of Gothic style; rather a true monumentality emerges, inspired by the classical world. It is not impossible that the terracotta itself, which had not been used in the figurative arts all through the Middle Ages, was prized by Donatello and his contemporaries for the favour it enjoyed in classical antiquity.

The Florentine sculptor has endowed his figures with deep humanity: the Virgin is humble, caring, while the Child turns with great naturalness towards the viewer. Later, Donatello would not so much represent Madonnas standing, preferring to focus more closely on the bond between mother and son.

Donatello in San Martino

Virgin and Child, c. 1410–2

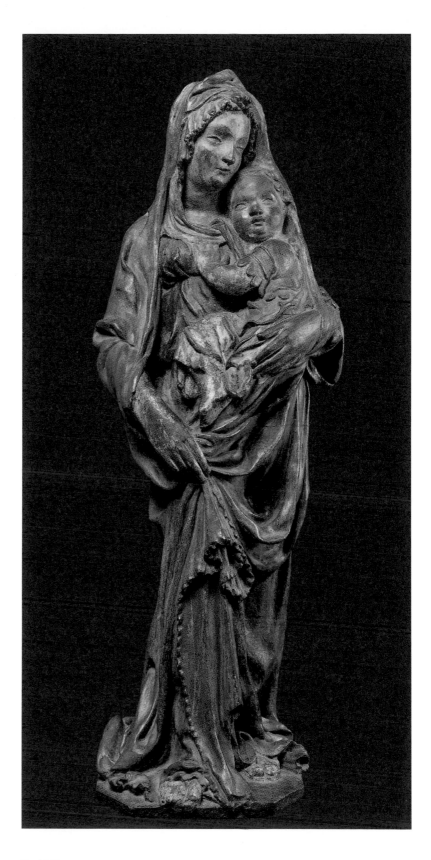

San Martino

PRATO
Museo di Palazzo Pretorio

Neville Rowley

In the Museo di Palazzo Pretorio in Prato there is a terracotta **tabernacle** of capital historical importance. It is one of the rare terracotta works by Donatello that can be dated with relative certainty, being from about 1417. The two angels that flank the Virgin and the Child in fact almost match the princess carved in the relief of *Saint George and the Dragon*, in the predella of the niche of the Arte dei Corazzai e Spadai in the church of Orsanmichele, documented in that year (and today in the Bargello; pp. 59–62, 67 and 71). At the time, Donatello worked regularly with Filippo Brunelleschi: the two artists had formed a *compagnia* (partnership) around 1410 for two statues, *Saint Peter* and *Saint Mark* (pp. 56–9, 63 and 65), also in Orsanmichele. Though this partnership was dissolved the following year or soon after due to financial disagreements, the two friends remained close: in 1419 Donatello participated in the creation of a model for the dome of Florence Cathedral, which would become the masterpiece of Brunelleschi and of Renaissance art as a whole.

The Prato relief testifies to these continuous exchanges between sculpture and architecture. The figures are in fact set in an ancient niche, with a degree of archaeological study that is baffling for the art of the time. Pillars and capitals seem to be copied directly from Roman monuments; as for the frieze that runs along the base of the relief, it repeats the play of perspective partly used in the niche of *Saint Peter* in Orsanmichele, spatial exercises that underlay the invention of mathematical perspective in those same years.

The most remarkable detail appears in the two prophets set in the spandrels of the niche, who are gazing with great assurance at the sacred figures. The fact that they were only sketched in suggests that the tabernacle may have been conceived as a model for a larger work in stone, comparable to the niches of Orsanmichele.

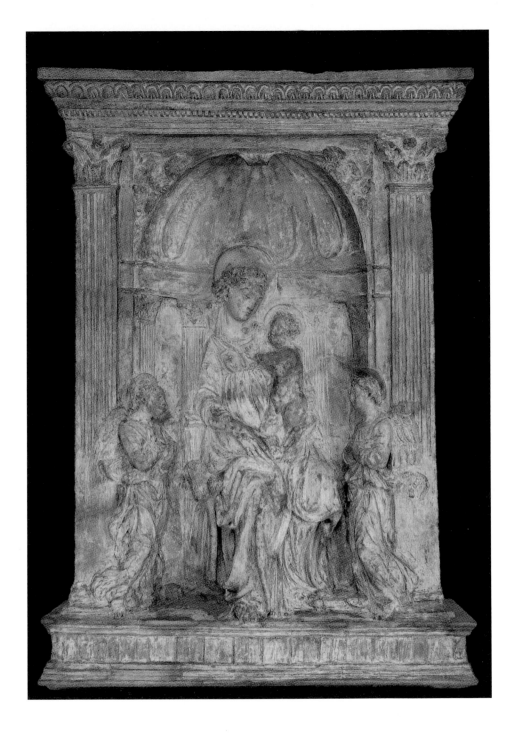

Donatello in the Museo di Palazzo Pretorio

Virgin and Child, Two Angels and Two Prophets, c. 1415–20

PRATO
Cathedral and Museo dell'Opera del Duomo

Neville Rowley

1.
Donatello
and Michelozzo,
*Pulpit of the Holy
Girdle*, 1428–38
(present state,
with original parts
and parts consisting
of copies)

The **pulpit** of Prato, intended for the public display of the city's most important relic, the girdle of the Virgin, is certainly one of Donatello's most important creations. Today it can be seen in part at the Museo dell'Opera del Duomo, for the marble and bronze reliefs, but the whole complex can only be fully understood in its historical site, on the right-hand corner of the cathedral facade, where the original reliefs have been replaced by copies (fig. 1).

The work should not be regarded as by Donatello alone, since it was a collective effort. In the mid-1420s, Donatello felt the need to form a *compagnia* (partnership) with Michelozzo, ten years his younger, to cope with the many commissions he could no longer manage on his own. It is clear that at first this solution seemed to bear fruit. Not only did the new partners complete two impressive commissions, the tomb of Cardinal Baldassare Coscia for the baptistery in Florence (pp. 12–3 and 14) and that of Cardinal Rinaldo Brancaccio in the Neapolitan church of Sant'Angelo a Nilo, but at the same time Donatello was able to work on public commissions, such as the decoration of the baptismal font in Siena (pp. 132–9), as well as producing works for private devotion. The first successes, however, led the two artists to unduly delay other commitments, as shown by events in Prato.

Although it was Michelozzo who signed the contract for the commission on behalf of the partnership in July 1428, the documents leave little doubt that Donatello played a leading part in the undertaking. The initial agreement contracted for the creation of a pulpit, probably already circular, comprising six reliefs decorated with pairs of putti bearing the heraldic emblems of the city of Prato. The multiplication of this figurative scheme may appear rather repetitive, but the conception of the three putti supporting coats of arms on the crozier of the *Saint Louis of Toulouse* for Orsanmichele (pp. 48–9, 51 and 63) suggests how Donatello might have given life and variety to that programme.

[1]

Cathedral and Museo dell'Opera del Duomo

[2]

2.
Donatello
and Michelozzo,
Capital of the Pulpit
of the Holy Girdle,
1433

Donatello and Michelozzo were meant to deliver the pulpit by September of the following year but the work dragged on. An architectural structure involving complex problems in statics and technology certainly lay outside the scope of the two masters' customary work. Other commissions also got in the way. In 1429, for instance, Donatello completed his bronzes for the baptismal font in Siena. In 1432, nothing had yet been consigned. But worse followed: in the autumn of that year, Donatello had for months been absent from Florence, where the work was being done on the reliefs for Prato, having travelled to Rome, probably with Michelozzo himself. This was too much for the patrons in Prato, who used every means to bring the two artists back to a sense of the engagements they had entered into. Their collaborator Pagno di Lapo Portigiani was sent to Rome in the following months, bearing a letter from Cosimo il Vecchio de' Medici addressed to Donatello. In the spring of 1433 he finally returned to his native city.

By this time the work seems to have been progressing rapidly. At the year's end Michelozzo cast the capital for the base of the pulpit (fig. 2), while in May 1434 a new contract was signed, this time with Donatello alone. There would no longer be six but seven marble reliefs, and the

putti supporting heraldic emblems would be replaced by 'stories' (*storie*) of dancing *spiritelli*. This iconographic change was due to the sculptor, who had been able not only to appease his clients and their remonstrations over the alarming delays in completing the work, but actually to persuade them of the importance of depicting a wild bacchanal of putti on their pulpit rather than a sober display of civic emblems. This episode clearly shows that Donatello saw himself not as a dilatory craftsman who had fallen behind in his work, but as a demiurge capable of deciding the schedule to suit his inspiration.

Despite the promises, work on the pulpit for Prato lasted another four long years. This time, it was not because of a new journey, but an important commission, the organ loft in Florence Cathedral (pp. 34–7, 42 and 44–5); the work contained an architectural part, for which Donatello must have felt the assistance of his partner Michelozzo was no longer required. The commission seemed expressly planned to exasperate the authorities in Prato. Not only was it a potential obstacle capable of delaying the delivery of their pulpit, but the iconographic programme was all too similar, envisaging a dance of *spiritelli* extending the full width of the work, with a joy and modernity that made the Prato pulpit seem outdated even before it was installed. Among the first to realise this was one of the assistants of Donatello and Michelozzo, Maso di Bartolomeo, commissioned to create the reliquary to hold the Virgin's precious girdle in Prato Cathedral. He depicted *spiritelli* running all around the box decorated with pairs of small columns, a direct reference to the Florentine *Cantoria*, not the pulpit in Prato.

The repeated references in documents to Maso di Bartolomeo, as well as Pagno di Lapo Portigiani and other assistants, show that the partnership's work was not carried out solely by the two principals of the *bottega*. Critics have wasted much time attributing this or that relief on the pulpit in Prato (figs. 3–4) to one or the other, while all the pieces should be seen as an essentially collective creation. The invention was certainly Donatello's, and Michelozzo's role was not negligible, but the variations in quality indicate broad participation by many assistants.

The pulpit in Prato was finally completed in September 1438. What had long seemed a failure foretold proved to be one of Donatello's most remarkable creations. The influence of the work in Prato was all the more important because of the delay in completing it, since while the reliefs were in Donatello's Florentine workshop some of them were copied by other artists. For Donatello, the difficulties in completing the work were not a lesson learnt. The commission for the door of one of the sacristies in Florence Cathedral was similarly left on hold for many years, this time in vain. It would, however, be unfair to consider the sculptor as alone responsible for the failures to complete his works. In April 1455 he and

[3]

[4]

3.
Donatello
and Michelozzo,
Dance of Spiritelli
(from the *Pulpit
of the Holy Girdle*),
1434–8

4.
Donatello
and Michelozzo,
Dance of Spiritelli
and *Double Fluted
Pilaster* (from the
*Pulpit of the Holy
Girdle*), 1434–8

Michelozzo wrote to the authorities in Prato, proposing to finally clear the arrears of work relating to the pulpit. But the letter was never delivered, because Filippo Lippi, who was working on the fresco decoration of the main chapel of Prato Cathedral, and so had the task of handing it to the recipients, simply forgot to deliver it. It took a twist of fate for the pulpit in Prato to remain forever an unfinished masterpiece.

Donatello in the cathedral and in the Museo dell'Opera del Duomo

Donatello and Michelozzo
Pulpit of the Holy Girdle, 1428–38
[1–4]

PISA
Museo Nazionale
di San Matteo

Neville Rowley

A Roman legionary martyred under Diocletian after he converted to the Christian faith, Luxorius was particularly venerated in his native Sardinia as well as in Sicily and Pisa, where he was called Rossore. The relic of his skull was previously preserved in Pisa but transferred in 1422 to the Humilati friary in Florence, where Donatello was asked to create a gilded bronze reliquary for it. First placed on the counter-facade of the Florentine church of Ognissanti, the **bust** was then moved to the church of Santo Stefano dei Cavalieri in Pisa in 1591, and to the present museum in 1977.

In this work Donatello followed the long medieval tradition of the reliquary bust: the back of the head opens to insert the precious relic. At the same time, the artist gave his saintly soldier a remarkable vital energy. His armour emerges from beneath the cloak in a way very true to life, while the features are surprisingly realistic. Rossore seems to be absorbed in harsh and melancholy reflection on his destiny.

At the time, independent portrait busts did not exist or were very rare: it was Donatello's genius that invented a genre that would be widely practised in Europe for many centuries. In fact critics have often lost themselves in speculation about the modernity of this head, which has sometimes been dated several centuries later than it was made, even though it is well documented.

Donatello in the Museo Nazionale di San Matteo

Reliquary of Saint Rossore, c. 1422–5 (from Pisa, Santo Stefano dei Cavalieri; formerly in Florence, Ognissanti)

SIENA
Baptistery

Gabriele Fattorini

D

1.
Lorenzo Ghiberti,
Jacopo della Quercia,
Donatello, Giovanni
di Turino and Goro
di ser Neroccio,
Baptismal Font,
1416–34

The Siena Baptistery preserves one of the most extraordinary monuments of the early Renaissance: a baptismal font erected between the second and third decades of the fifteenth century, in which Donatello played the dominant part, vying with Lorenzo Ghiberti and Jacopo della Quercia in a contest that pitted the greatest sculptors of Tuscany, and therefore Europe, against each other. The complex, with a hexagonal plan, consists of a basin and a marble tabernacle, accompanied by sculptural elements in bronze and marble (fig. 1). Set on the axis between the main portal and the apse, the font stands in the middle of the sanctuary, housed in a space below the terminal area of the cathedral and divided into a nave and side aisles.

Together with the Fonte Gaia, completed in 1419 by Jacopo della Quercia, and the Loggia della Mercanzia, the baptismal font was one of the great Sienese civic projects in the first half of the century. It was begun by the *operaio* (overseer) of the cathedral's fabric Caterino di Corsino in 1416. He entrusted the construction of the basin to Sano di Matteo of Siena, Nanni di Jacopo of Lucca and Jacopo di Corso of Florence, under Ghiberti's supervision. At the time Ghiberti was the most successful of Florentine artists, engaged in the work on the North Door of the baptistery (1403–24). He must have drawn on this model for the idea of embellishing each of the six sides of the basin with panels cast in bronze depicting an episode from the life of John the Baptist, the Pieve's patron. In 1417 the commission for the six stories was divided between Ghiberti himself, Jacopo della Quercia and the Sienese goldsmith's workshop of Turino di Sano and his son Giovanni, fixing a term of ten months for the supply of each piece. This deadline, however, was not respected, and in 1423 the commission for one of Jacopo della Quercia's two panels passed to Donatello. The panels were finally delivered in 1427, with the exception of that by Jacopo. He set to work soon after and it was placed on the font in 1430.

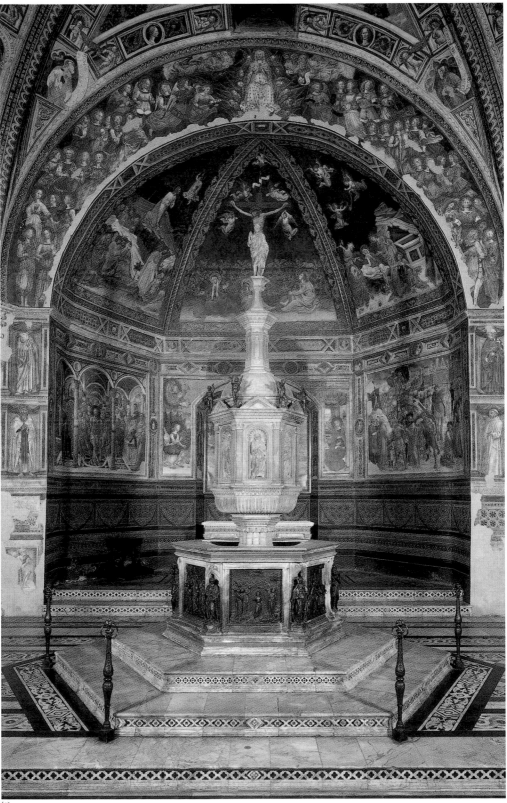

[1]

[2]

2.
Feast of Herod,
1423–7

The cycle recounts six episodes from the story of the Baptist, reading anticlockwise from the wall facing the apse with Jacopo's *Zachariah in the Temple* and continuing with the *Birth* and the *Baptist Preaching* by Giovanni di Turino (who executed the work instead of his father), the *Baptism of Christ* and the *Baptist before Herod* by Ghiberti, and finally the *Feast of Herod* by Donatello. As one walks around the font it is clear that the narrative develops through different styles, and that the work was initially animated by the spirit of Ghiberti's North Door, finding its final point of reference in Donatello's innovative perspective vision.

Ghiberti had finished the *Baptist before Herod* by 1425 and it was chased with the assistance of Giuliano di Ser Andrea. The composition derives from the *Christ before Pilate* on the North Door, while it also attempts to adopt the innovations by Brunelleschi and Donatello in the hints at a three-dimensional treatment of the architectural setting, enlivened by round-headed arches and adorned with a frieze of bucrania in antique style. Also reminiscent of the style of the North Door are the *Birth* and the *Baptist Preaching* by Giovanni di Turino, a goldsmith who here reveals all his feebleness, plagiarising certain Ghibertian inventions in

3.
Faith, 1427–9

4.
Hope, 1427–9

that model for some details of his reliefs. Ghiberti himself, again by 1425, had cast the very fine *Baptism of Christ*: a crucial episode, placed in a position of honour on the wall towards the entrance, alluding to the function of the font. Ghiberti devised a new and very refined artistic language, resting on a Gothic linearism of extreme subtlety in depicting Christ isolated in the waters of the Jordan as he is baptised by John, who reaches out a long and very fine arm over him. Equally elegant are the figures of bystanders and the angels gathered in a cloud that translates Donatello's *stiacciato* into pictorial terms. Leaving the North Door behind, this is the prelude to the Door of Paradise, commissioned from Ghiberti in Florence also in 1425.

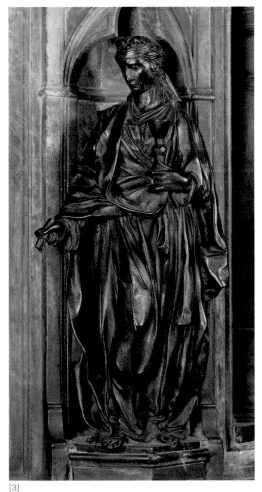

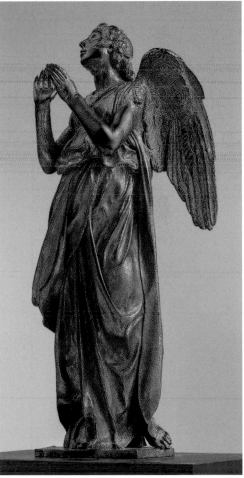

[3]

[4]

Ghiberti, in his own way, reacted to Donatello's innovations, culminating in Siena in the **Feast of Herod** (fig. 2), gilded by Giovanni di Turino and delivered in 1427. This panel perfects the experiments in the predella of the *Saint George* in Orsanmichele (c. 1415–7; pp. 59–62, 67 and 71), through a bas-relief resting on very shallow carving with the *stiacciato* technique. It favoured the construction of perspective, within which the narrative is articulated in different times and planes. On the proscenium, at left, the head of the Baptist is presented to Herod, who reacts with disgust; Salome opposite performs a dance step, in the midst of a group of guests around the table, some of whom cover their faces to blot out the horror. In a setting in ancient style, with round-headed arches and carefully studied foreshortened elements, we see a musician and two onlookers, and behind them appear other rooms of the building, revealing a staircase leading to the upper floors, and yet another portico where the severed head of the Precursor is shown to Herodias, the first episode in the story. In contriving such an articulation of spaces, figures and actions, Donatello reveals exceptional skill in staging the scene, heightening the expressive quality that he had nurtured since the *Crucifix* in Santa Croce (pp. 51–3) to bring out fully the grime atmosphere in which the Baptist's tragic destiny is fulfilled.

That this was a successful formula is confirmed by Jacopo della Quercia's clumsy attempt to reproduce Donatello's spatial quality and *stiacciato* in the *Zachariah in the Temple*, in which the finest parts are those where the Sienese sculptor followed his instinct, vigorously expressing the poses of the figures and energetically billowing out the folds of their garments. As he had shown in the Fonte Gaia and the portal of the basilica of San Petronio in Bologna, Jacopo was a sculptor who loved working with marble and sculpture that involved 'carving away' the material. Here in the font he did his best work in the design of the hexagonal tabernacle, commissioned in 1427 and completed with the help of assistants by April 1429, placing a statue of the Baptist at the top. Note especially the *Prophets* sculpted on five of the six sides, animated by a resolute pre-Michelangelesque vigour. They are set within aedicules that emulate the classical restraint of those studied by Donatello for the *Virtues* sculpted by his partner Michelozzo at the base of the funerary monument of Baldassare Coscia in Florence Baptistery (c. 1422–8; pp. 12–3 and 14).

Meanwhile, the sculpting of the six *Virtues* to be set in the Gothic niches at the edges of the basin below confirmed Donatello's success to the detriment of Ghiberti. The statuettes were meant to be commissioned from Ghiberti, but the Opera del Duomo, wearied by his delays and requests for money, expelled him from the work and began by ordering two of them from Donatello. The result was that, between 1427 and 1429, he created the first two examples of bronzes conceived in the round in

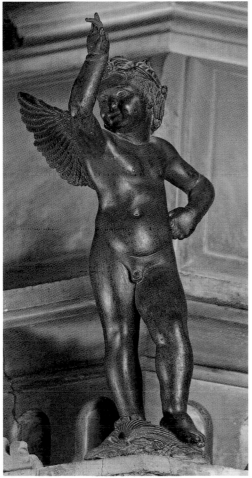

[5]

[6]

5.
Dancing Spiritello,
1429

6.
*Spiritello
with Trumpet*,
1429

the modern age. They are **Faith** and **Hope** (figs. 3–4), which project at the sides of Ghiberti's *Baptist before Herod*, seeking to take possession of the space and distinguished by their classical restraint, freedom of movement and the vibrant pictorial and material effect, rendered in the rippling of their garments. Holding the chalice in her left hand, *Faith* is posed with extreme grace, turning her head to her right, where she once had a cross, of which only the socket that it was set in remains. *Hope* has dishevelled locks and seeks comfort from heaven with clasped hands, almost as if about to take flight outside the aedicule. Giovanni di Turino fashioned three further *Virtues* between 1429 and 1431, which express the effects of these innovations: *Justice* and *Charity* are still modelled in the manner of Ghiberti, while *Prudence* is clearly affected by Donatello's example with her bare feet and in the articulation of her garments. The cycle ends with a delightful *Fortitude* by Goro di Ser Neroccio (1428–31). An established Sienese goldsmith working in the Gothic tradition, he deviated from his canons by presenting a figure so close to Donatello's *Virtues* that one suspects it may have been cast following a model by the Florentine sculptor.

7.
*Spiritello with
Tambourine*, 1429
Berlin, Staatliche
Museen,
Skulpturensammlung
und Museum für
Byzantinische Kunst

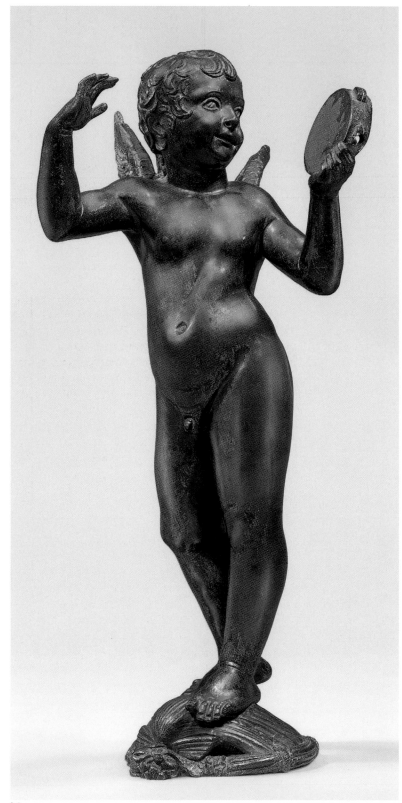

[7]

Then six bronze *Spiritelli* were placed at the corners of the top of the tabernacle, sculpted in the round in the act of making music, dancing and playing. Three of these were made in 1429 by Donatello: a ***Spiritello with Trumpet*** and a ***Dancing Spiritello*** (who has an autograph twin, which was never installed, in the Museo Nazionale del Bargello, pp. 72 and 74) are still on the font, while the celebrated *Spiritello with Tambourine* is now in the Bode-Museum in Berlin (figs. 5–7). In the homage they pay to ancient models, their concrete placing in space and tender naturalistic feeling, these figures are one of the summits of early Renaissance sculpture, anticipating the unbridled joy of the *Cantoria* in Santa Maria del Fiore (pp. 34–7, 42 and 44–5) and the affirmation of the genre of the bronze statuette in fifteenth-century Italy. In completing the cycle in 1431 with three more *Spiritelli* (one of which is lost, while the others are still on the font), Giovanni di Turino could hardly help drawing on these examples, becoming a follower of Donatello by compliance.

In the light of all this, it is rather surprising that the Opera del Duomo rejected a door that Donatello had delivered in 1429 for the tabernacle, with a bronze door by Giovanni di Turino (1434) being installed in its place. This portrayed a *Virgin and Child* which reverted to Ghibertian qualities, finally concluding the work. In this way the font became the boast of a city that Donatello had guided towards a new artistic season, and where he would return between 1457 and 1461, attracted by ambitious projects for the cathedral (pp. 140–9).

Donatello in the baptistery

Feast of Herod, 1423–7
[2]

Faith, 1427–9
[3]

Hope, 1427–9
[4]

Dancing Spiritello, 1429
[5]

Spiritello with Trumpet, 1429
[6]

SIENA Cathedral and Museo dell'Opera della Metropolitana

Gabriele Fattorini

1.
Virgin of Pardon,
c. 1458

Founded by Pope Alexander III on 18 November 1179 and dedicated to the Assumption of Mary, Siena Cathedral is one of the most illustrious churches in Italy, partly due to its majestic Gothic facade, designed by Giovanni Pisano in the late thirteenth century. In the autumn of 1457 Donatello, now seventy years old, moved his workshop from Florence to Siena, with the idea of leaving his mark on that monumental elevation. The Opera del Duomo had commissioned the bronze doors of the cathedral from him, evidently wishing to emulate the achievement of Lorenzo Ghiberti in the North Door (1403–24) and the Door of Paradise (1425–52) of the Florentine baptistery, but with the fierceness that Donatello had expressed in the pair of doors cast in the early 1440s for the Old Sacristy of San Lorenzo (pp. 97–9 and 101). Unfortunately, the project proved unsuccessful. The cost was too much for the Opera del Duomo, and perhaps the effort was too much for the elderly master, though he found a series of artificers in Siena, ranging from the well-known Lorenzo di Pietro, called Vecchietta, to the young Francesco di Giorgio, who held him in high regard, assisting and emulating him in bronze. Besides, it was not the first time that the sculptor had worked in the city: thirty years earlier he had indelibly marked Siena's artistic life by revealing the potential of the new Renaissance vocabulary in the baptismal font of the Pieve (pp. 132–9), with the panel of the *Feast of Herod* (1423–7) and a series of bronzes (1427–9): *Faith* and *Hope* looking out of the niches of the basin, and three *Spiritelli* on the crowning (two are still in place, the third is in the Bode-Museum in Berlin).

Now the Florentine master returned to Siena burdened with years but strengthened by long experience in Padua (1443–54), which had seen him essentially delight in bronze, and making his style more aggressive, tactile and visionary than ever, though always remaining firmly within a rational perspective scheme. In the Victoria and Albert Museum in Lon-

[1]

don there is a tragic bronze *Lamentation over the Dead Christ*: the unrestrained despair expressed by the group of mourners evokes the work of the Paduan period, but is believed to be a sketch by Donatello for one of the panels for the doors of Siena Cathedral. If that were indeed the case, we would be faced with the only surviving evidence of an undertaking that was as ambitious as ever but came to nothing.

However, the Opera del Duomo profited by the presence of Donatello, who stayed in Siena until 1461, to complete its grandiose project of erecting an altar in Renaissance style – the first of its kind in the city – to honour the painting known as the *Madonna del Voto* or *Madonna delle Grazie*, still the Marian image most venerated by the Sienese. Depicting the Virgin and Child on a gold ground, it is attributed to Dietisalvi di Speme and was painted shortly after 1278 as the central feature of an altarpiece, reduced over time, out of veneration for the Virgin, to the central icon alone, sacrificing the saints at the sides. Today the *Madonna del Voto* is revered at the centre of a baroque chapel, built by the right transept in the 1660s at the behest of the Sienese Pope Alexander VII (1655–67; Fabio Chigi) and with the contribution of Gian Lorenzo Bernini (who executed the statues of *Saint Jerome* and *Mary Magdalene*). At that time Renaissance forms were no longer fashionable, and the old fifteenth-century chapel – the one that concerns us here – was dismantled. It was set in the third bay of the right-hand aisle, soon renewed with the altarpiece by Raffaello Vanni illustrating the *Ecstasy of Saint Francis de Sales* (1668–70), shortly after being canonised by Alexander VII in 1665.

Fortunately there are several images of the interior of Siena Cathedral, painted between the late fifteenth century and the early decades of the sixteenth, which record the appearance of the Quattrocento chapel of the Madonna delle Grazie. The earliest and the most faithful is a panel by Pietro Orioli, painted in 1483 for the office of the Gabella of the municipality and now in the Archivio di Stato. It is like a snapshot of the interior of the cathedral, focused on the altar of the Madonna delle Grazie, where the highest civic and ecclesiastical institutions are shown making an offering to the icon of the Virgin, which miraculously comes to life to receive it. In the right-hand aisle of the cathedral we can see the hollow space of the altar, framed by a great architecture in ancient style with a round-headed arch, pilasters and entablature, composed of marble carved from 1451 on by Urbano da Cortona: a master who had been one of Donatello's assistants in Padua and was probably recruited by the Sienese authorities on his recommendation. Following the demolition of the architecture framing the altar in the seventeenth century, Urbano's sculptures were reused extensively in the cathedral: six half figures of saints ended up above the architraves on the side portals of the facade, while the many *Stories of the Virgin* that adorned the pilasters are set in

the wall by the door of the bell tower, at the sides of the main portal in the counter-facade and in the balcony above. One of these – an *Annunciation of the Death of the Virgin*, clearly inspired by Donatello's *Feast of Herod* in the baptistery, rather like all the other episodes – is exhibited in the Museo dell'Opera, together with one of the symbols of the Evangelists from the entablature, and the tondo depicting the *Virgin and Child* from the cornice of the chapel.

When Donatello arrived in Siena, it was clear that Urbano was completing a task that he would have performed far more successfully, but at that point it could hardly have been begun again. Hence he limited himself to carving a tondo of the **Virgin and Child** to replace that by Urbano at the centre of the tympanum. Today it is among the masterpieces in the Museo dell'Opera (fig. 1). The tondo is known as the *Virgin of Pardon* (*Madonna del Perdono*), because once it had been removed from the altar of Santa Maria delle Grazie it ended up on a side entrance of the cathedral, called the Porta del Perdono (where a copy replaces it today). The difference between Urbano's marble and Donatello's is disconcerting. Urbano's figures seem almost like puppets compared to the brilliant invention of the Florentine master, wholly developed on perspective and natural effects. With a foreshortened representation carefully studied to be seen from below, the *Virgin of Pardon* emerges with formidable energy from a three-dimensional oculus, decorated with coffering in antique style. The Virgin is depicted half-length with a sharp outline of the face that recalls the *Judith* (begun in Florence for the Medici just before leaving for Siena; pp. 112 and 114–7). Seated in three-quarter view on the clouds, she turns to gaze at her son, who clings to her in a precarious balance, but held securely by his mother's strong hands. The full cloak that falls from Mary's head follows the forms of her body, as if wet, conveying the pictorial effect of bronze, while Donatello actually carved it in marble – a very rare event in the last phase of his career – depicting with the help of assistants some evanescent heads of cherubs or seraphs in the background, with the *stiacciato* technique.

That piece, once mounted in the tympanum in 1459, was immediately successful among Sienese artists. Matteo di Giovanni depicted a variant with the figures reversed of the *Virgin of Pardon* in the altarpiece he painted in 1460 for the baptistery (now in the Museo dell'Opera), while Vecchietta echoed the glimpse of the arch with coffering in the gold of the side panels of the altarpiece with the *Assumption* in Pienza Cathedral, consecrated in 1462 by Pope Pius II (1458–64; the Sienese Enea Silvio Piccolomini, well known as a celebrated humanist before his election). Moreover, Pius II, together with the elderly Donatello, helped to give a new Renaissance turn to the arts in Siena around 1460.

In those years the cathedral of Siena appeared as depicted by Pietro

2.
*Floor Tomb
of Bishop Giovanni
Pecci* († 1427),
c. 1448–50

[2]

Orioli in the Gabella of 1483, where we can recognise the typical medieval bichrome architecture of the interior and, in the distance, the oculus with the window by Duccio (*post* 1288; now in the Museo dell'Opera and replaced by a replica). Just below we can glimpse the *Maestà* by Duccio himself (1308–11; also in the Museo dell'Opera), at that time set on the high altar, and closer to us is a wall that divided the nave from the area reserved for the fourteenth-century canonical choir (destroyed in 1506). On its edge rose the pulpit by Nicola Pisano, moved to its current position in the sixteenth century. In the very centre of the sacred space of the canonical choir and in front of Duccio's *Maestà*, was another work by Donatello: the **floor tomb** of Bishop Giovanni Pecci (fig. 2).

This is a monumental bronze, cast in three pieces. Today it is set before the altar of Saint Ansanus, on the left side of the crossing, since the powerful Pecci family had the honour of obtaining the patronage of that chapel and moved the memorial of their illustrious ancestor there following the sixteenth-century demolition of the choir. For a long time it was believed that Donatello had cast this work around 1427, the year of the bishop's death, when he was working on the baptismal font. More recent investigations, however, have shown that the bronze must have been sent from Padua in the middle of the century and assembled in about 1452, because in the years just after this the leading sculptors active in Siena began to replicate the original treatment of perspective devised by the Florentine master for the tomb. Until then, burial slabs, usually made of stone, provided a simple two-dimensional silhouette of the deceased, accompanied by a Gothic architectural frame and inscriptions. Donatello, who had already begun to dismantle this tradition in the tombs of Giovanni Crivelli (1432; Santa Maria in Aracœli) and Martin V (by 1445; San Giovanni in Laterano) in Rome, resolutely renewed the genre, with a new perspective treatment that encouraged the involvement of the viewer.

Whenever we observe this bronze, it is as if we were reliving the funeral of Giovanni Pecci. It represents the moment of the viewing of the deceased before the altar. Lying serenely in his rich episcopal robes and with his hands clasped, the prelate is represented in his coffin, clearly recognisable by the staves supporting it at the sides and the trestle beneath, skilfully foreshortened, as are the figure's feet. The head rests on a pillow placed in a scallop at the top of the niche in antique style that configures the interior of the coffin. The drapery forms dense folds with a lively pictorial effect, which must originally have been heightened by the glittering of the enamels that coloured the inserts in the mitre, the collar and the Pecci family's two coats of arms set at the base. The heraldic shields flank the dedicatory epitaph, carved on a scroll unrolled by two tiny putti, studied almost zenithally to again convey a sense of depth, as well as the scroll itself, allowed to partially cut off the signature 'OPVS

[3]

3.
*Saint John
the Baptist*,
1455 c.–1457,
1465

4.
Cathedral,
Chapel of Saint
John the Baptist,
exterior

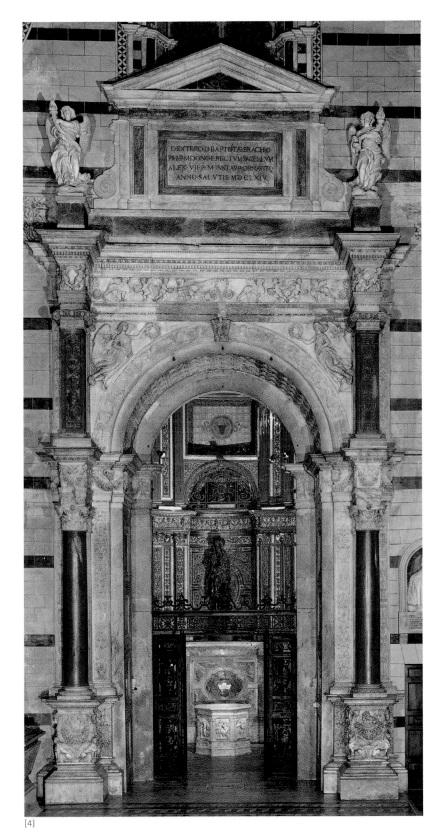

[4]

DONATELLI' carved in the panel below. The lettering is in Latin capitals, which Donatello – like a humanist – had now made his own, and they recur in the epitaph ('REVEREN[do] D[omi]NO D[omino] IOHANNI | PECCIO SENEN[si] APOSTO|LICO P[ro]TONOTARIO EP[iscop]O G|ROSSETANO OBEVNTI | K[a]L[endis] MARTII MCCCCXXVI'). This pays homage to the reverend Giovanni Pecci, apostolic protonotary and bishop of Grosseto, who died at the kalends of March 1426, or 1 March 1427, since in the ancient Sienese state the New Year began not on 1 January but on 25 March, the feast of the Annunciation.

Donatello left Siena, never to return, in 1461, leaving a bronze statue of *Saint John the Baptist* that he had brought with him from Florence four years earlier, and consigned to the Opera del Duomo on 24 October 1457, still in three pieces, as he had cast it. The statue was assembled only after his departure, with the awkward addition of the right arm in the act of blessing, which we know was chased and finished in 1465 by a certain Jacopo di Feltrino from Ferrara.

The statue in question is the **Saint John the Baptist** placed at the centre of the chapel of the saint by the left transept of the cathedral (figs. 3–4). It is the figure of a penitent burnished in bronze, with the surfaces rough, not always fully cleaned of the defects from casting, excessive in the extremely Donatellian expressive canon. It has precedents in the figures on the doors of the Old Sacristy of San Lorenzo in Florence (pp. 97–9 and 101), in the *Saint John* in the church of the Frari in Venice (1438) and in the haggard *Mary Magdalene* sculpted in wood in the Museo dell'Opera del Duomo in Florence (pp. 13–5, 42 and 44), and looks ahead to the merciless Medici *Judith*, completed on his return home (pp. 112 and 114–7). Here we have a Saint John exhausted by life in the desert; his feet are bare, he holds a cross in his left hand, and his lips are parted in a sigh, his eyes are hollow, his camel-hair garment is thick and matted, and his long hair dishevelled and tangled.

For some fifteen years there has been much discussion about whether this wild and hallucinated Precursor, with a monumental dimension, was not designed by Donatello to be placed above one of the doors of the baptistery in Florence: a first idea to take the place of the fourteenth-century groups by Tino di Camaino, replaced by those by Giovanfrancesco Rustici, Andrea Sansovino and Vincenzo Danti only in the sixteenth century. However, in Siena the statue had to wait some decades before receiving its definitive arrangement in a large circular chapel dedicated to Saint John the Baptist, which honours the relic of the right arm of the Precursor donated to the cathedral by Pius II in 1464 and preserved in an adjacent chapel. Built at the behest of the *operaio* (overseer) of the cathedral Alberto Aringhieri, who as a Knight of Jerusalem was devoted to the Baptist, and of Archbishop Francesco Tedeschini Piccolomini, in 1501

the chapel received Donatello's bronze and the marble statues of *Saint Catherine of Alexandria* by Neroccio di Bartolomeo and *Saint Ansanus* by Giovanni di Stefano, set in the lateral niches. Then in 1504 Bernardino Pinturicchio frescoed the walls with the *Stories of the Baptist* (partly repainted in the following centuries) and the portrait of Aringhieri.

At the centre of the chapel stands a stoup for the water of Easter Saturday decorated with a series of *Stories from Genesis* and *Stories of Hercules* carved in marble in about 1460 by Antonio Federighi. A Sienese sculptor of immense talent, he began as a follower of Jacopo della Quercia and emerged as one of the greatest sculptors in the ancient style of his time. The clear difference between this complex and the bronze statue of *Saint John* clearly records the way that artistic Siena, under the impress of the papacy of Pius II and Donatello's last stay in the city, was capable of experimenting with varied approaches on the highest level to the new Renaissance language.

Donatello in the cathedral

Floor Tomb of Bishop Giovanni Pecci († 1427), c. 1448–50
[2]

Saint John the Baptist, 1455 c.–1457, 1465
[3]

Donatello in the Museo dell'Opera della Metropolitana

Virgin of Pardon, c. 1458 (from the Porta del Perdono in the cathedral; formerly on the facade of the chapel of the Madonna delle Grazie)
[1]

AREZZO
Cathedral

Neville Rowley

Writing in the mid-sixteenth century, in his *Life of Donatello*, Giorgio Vasari mentions a bas-relief of the **Baptism of Christ** on the baptismal font of Arezzo Cathedral, and attributes it to the brother of the Florentine sculptor, a certain Simone. The existence of this alleged brother has not been proved by the documents; consequently, the baptismal relief has often been neglected in Donatello studies.

This oversight is extremely damaging, since the work is of great interest and appears to be much more closely bound up with the world of the sculptor than the other marble reliefs on the same font. Some parts of the panel are in fact worthy of the utmost attention, such as the face of the Baptist, inherited from some ancient statue of a river god, or the clear profiles of the angels that surround the main figures, or again the monumental effect of the trees that surround the scene. All these features directly evoke Donatello's art in the second half of the 1420s, although most of the carving was probably performed by some assistant.

In this same decade, the Florentine sculptor was involved in the decoration of two other baptismal fonts. In 1423 he made a bronze statue of *Saint John the Baptist*. Intended to surmount the font in Orvieto Cathedral, it later became the property of the Martelli family in Florence. (It is now in the Pushkin Museum in Moscow, after being preserved in Berlin until the end of World War II.) Then, and most important of all, in the same year he began working on the baptismal font in Siena, in collaboration with Jacopo della Quercia and other masters (pp. 132–9).

The Arezzo relief is closely connected with another *Baptism of Christ* from the circle of Donatello, also in marble, now in the Berlin Museums.

Donatello in the cathedral

Donatello and collaborator
Baptism of Christ, c. 1425–30

TORRITA DI SIENA
Sante Flora e Lucilla

Neville Rowley

In the church of Sante Flora e Lucilla at Torrita di Siena, a lunette in the style of Donatello of the **Blood of the Redeemer** is displayed above a faithful copy by Fulvio Corsini dating from the 1920s. At the time, the intention was to substitute the copy for the original, and to sell the latter surreptitiously to some European museum or American magnate. Fortunately, the attempt was thwarted and the Quattrocento marble remained in its place.

The subject is relatively unusual, but not entirely absent in Quattrocento art. Christ is raised to heaven, and sheds his blood for the remission of the sins of mankind. We see an angel collecting the precious gift in a chalice. Although the execution is not always worthy of the master, the general composition and many details recall Donatello's masterpieces from the 1420s, such as the *Assumption of the Virgin* in the tomb of Cardinal Rinaldo Brancaccio (Naples, Sant'Angelo a Nilo) or the *Ascension with Christ Giving the Keys to Saint Peter* now in the Victoria and Albert Museum in London, but from Palazzo Medici in Florence. The body of Christ is a miracle of balance between a pose in contrapposto inspired by antiquity and a more naturalistic anatomy. Even the way of playing with the faux frame of the image is typical of Donatello. While the angels in the foreground at the sides seem almost external to the image, since they are standing on the frame itself, two heads rise above it, emerging from the earthly world, brilliantly framed in a way that would directly inspire many artists, from Andrea Mantegna to the baroque. These intruders have sometimes been mistaken for the Virgin Mary and Saint John, while they should be understood as portraits of the donor of the lunette and his wife, who had very likely intended the relief not for Torrita but some church in Siena.

Donatello in Sante Flora e Lucilla

Donatello and collaborator
Blood of the Redeemer, c. 1429–30

Index of Donatello's works in Tuscany

Suggestions for further reading

This bibliography, reduced to essentials, presents some reference texts, or at least the most up to date, for the inquiring reader who wishes to have a fuller understanding of Donatello and his works in Tuscany.

Giovanni Poggi, *Il Duomo di Firenze. Documenti sulla decorazione della chiesa e del campanile tratti dall'Archivio dell'Opera*, I, Berlin 1909; and II, posthumous edition edited by Margaret Haines, Florence 1988

Horst W. Janson, *The Sculpture of Donatello, Incorporating the Notes and Photographs of the Late Jenő Lányi*, 2 vols., Princeton 1957

Margrit Lisner, 'Die Skulpturen am Laufgang des Florentiner Domes', in *Mitteilungen des Kunsthistorischen Institutes in Florenz*, XXI, 1977, pp. 111–82

Ronald W. Lightbown, *Donatello & Michelozzo. An Artistic Partnership and Its Patrons in the Early Renaissance*, 2 vols., London 1980

Margaret Haines, 'La colonna della Dovizia di Donatello', in *Rivista d'arte*, s. IV, I (= XXXVII), 1984, pp. 347–59

Marco Collareta, *Donatello in Toscana: itinerario*, Florence 1985

Museo Nazionale del Bargello. Omaggio a Donatello. Donatello e la storia del Museo, exhibition catalogue (Florence, Museo Nazionale del Bargello, 19 December 1985–30 May 1986) edited by Paola Barocchi, Marco Collareta, Giovanna Gaeta Bertelà, Giancarlo Gentilini and Beatrice Paolozzi Strozzi, Florence 1985

Artur Rosenauer, *Donatello*, Milan 1993

Orsanmichele a Firenze, edited by Diane Finiello Zervas, 2 vols., Modena 1996

Francesco Caglioti, *Donatello e i Medici. Storia del David e della Giuditta*, 2 vols., Florence 2000

Da Jacopo della Quercia a Donatello: le arti a Siena nel primo Rinascimento, exhibition catalogue (Siena, Santa Maria della Scala, Opera della Metropolitana and Pinacoteca Nazionale, 26 March–11 July 2010) edited by Max Seidel, Francesco Caglioti, Laura Cavazzini, Elisabetta Cioni, Andrea De Marchi, Gabriele Fattorini and Aldo Galli, Milan 2010

Orsanmichele and the History and Preservation of the Civic Monument, conference proceedings (Washington, National Gallery of Art, Center for Advanced Study in the Visual Arts, 7 October 2005; Florence, 12–13 October 2006) edited by Carl Brandon Strehlke, *Studies in the History of Art*, 76, 2012

Lorenzo Sbaraglio, 'Una terracotta di Donatello: la Madonna dalla tomba di Giuliano Davanzati in Santa Trinita', in *Nuovi studi*, XVII, 18, 2012, pp. 37–82

The Years of the Cupola, 1417–1436, edited by Margaret Haines, 2015, available only online

Francesco Caglioti, Laura Cavazzini, Aldo Galli, Neville Rowley, 'Reconsidering the Young Donatello', in *Jahrbuch der Berliner Museen*, LVII, 2015 (2018), pp. 15–45

Francesco Caglioti, 'Donatello e il pergamo del Sacro Cingolo a Prato: una nuova lettera di Michelozzo (e altri chiarimenti documentari)', in Inedita mediævalia. *Scritti in onore di Francesco Aceto*, edited by Francesco Caglioti and Vinni Lucherini, Rome 2019, pp. 59–72

Francesco Caglioti, 'I pergami donatelliani di San Lorenzo nel contesto: architettura, liturgia, committenza', in *L'ultimo Donatello. I Pulpiti di San Lorenzo: studi e restauro*, edited by Maria Donata Mazzoni, Florence 2022, pp. 39–90

Donatello, the Renaissance, exhibition catalogue (Florence, Palazzo Strozzi and Museo Nazionale del Bargello, 19 March–31 July 2022) edited by Francesco Caglioti, with Laura Cavazzini, Aldo Galli and Neville Rowley, Venice 2022

Francesco Caglioti, 'Donatello e l'Opera di Santa Maria del Fiore: il maestro, i colleghi, i seguaci', in *Museo dell'Opera del Duomo, Firenze, catalogo generale*, Florence forthcoming

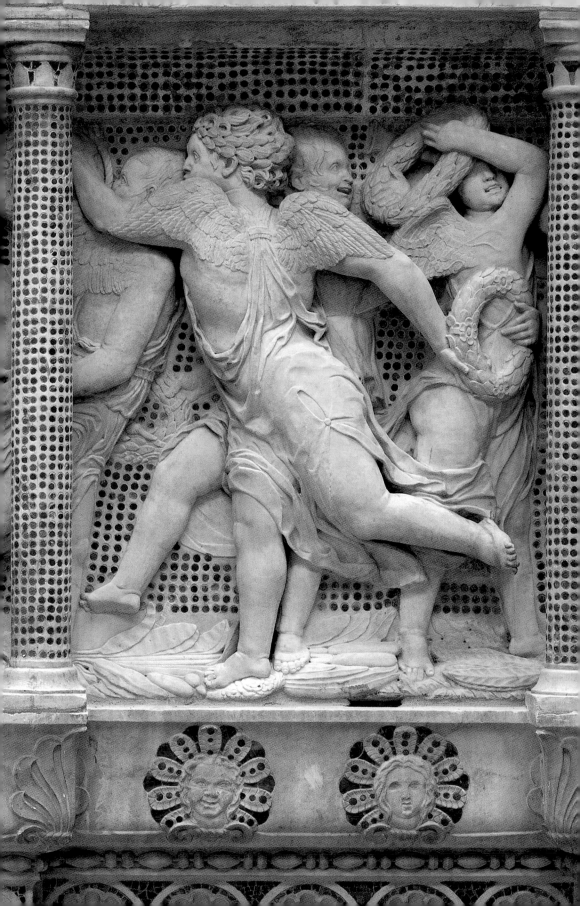

Timeline of Donatello

c. 1386
Donatello is born in Florence, the son of a wool comber.

1401–2
Competition for the second bronze door of the baptistery in Florence. Participants include Jacopo della Quercia, Filippo Brunelleschi and Lorenzo Ghiberti (the winner).

c. 1402–4
Donatello visits Rome with Brunelleschi to explore and study the city's ancient monuments.

1404–7
Donatello works in Ghiberti's workshop.

1406 November
He receives a down payment for two *Prophets* for the Door of the Mandorla on the north side of the cathedral, but he only makes one. Nanni di Banco carves the second some ten years later.

1408 winter
The Opera del Duomo pays him for another figure for the keystone in the arch of the door, a *Vir dolorum* whose style recurs in the Santa Croce *Crucifix*, faulted by Brunelleschi for its rustic nature.

1408–9
He carves a marble *David* for a buttress on the cathedral's north tribune but (like Nanni di Banco's *Isaiah* for the neighbouring buttress) it proves to be too small for such a lofty position.

1408 December
The *Evangelists* are commissioned for the cathedral facade: *Saint John* from Donatello, *Saint Luke* from Nanni di Banco, *Saint Mark* from Niccolò Lamberti and (1410) *Saint Matthew* from Bernardo Ciuffagni. They are unveiled in 1415.

1409–12
Donatello is paid for a large terracotta *Joshua* displayed from 1410 in place of the *David* (and worn by exposure to the elements down the ages).

c. 1410–2
Saint Peter for the niche of the Arte dei Beccai e Pesciaioli in Orsanmichele. The perspective marble inlay in the niche reveals the design of Brunelleschi, who is recorded as Donatello's 'partner' in the 'art of carving' in 1412.

1411–c. 1413
Saint Mark for the niche of the Arte dei Rigattieri e Linaioli in Orsanmichele.

1412
Brunelleschi has Donatello arrested for failing to pay him his due for certain 'work done together as partners'.

1415
The Opera del Duomo decides to complete the series of sixteen *Prophets* for Giotto's campanile. The first eight were installed on the two sides facing the baptistery and Piazza della Signoria respectively in the mid-fourteenth century. Donatello starts work on two *Prophets*, later christened the *Beardless Prophet* and the *Bearded Prophet*.

c. 1415–7
Saint George for the Arte dei Corazzai e Spadai in Orsanmichele. The niche itself is also by Donatello, unlike those for *Saint Peter* and *Saint Mark*.

1416
The *David* is moved to Palazzo della Signoria and Donatello completes the head of Goliath.

1417
The Opera del Duomo sells the Arte dei Corazzai e Spadai a block of marble for the base of the niche with *Saint George*. The predella depicting *Saint George and the Dragon* is the first instance of Donatello's use of the *stiacciato* technique.

1418
He completes the *Beardless Prophet*.

1419
Brunelleschi, Donatello and Nanni di Banco receive payment for a scale model of the cathedral dome that Brunelleschi is preparing to build (1420–36).

1420 winter
Donatello carves the *Marzocco* in *macigno* stone for the papal apartments prepared for Pope Martin V's stay in Florence in the convent of Santa Maria Novella. He also works on the most important niche in Orsanmichele, for the Parte Guelfa, to host *Saint Louis*, his first monumental figure in bronze (c. 1425).

1420
He finishes the *Bearded Prophet*.

1420–1
Donatello and Nanni di Bartolo complete a *Joshua* begun by Ciuffagni for the campanile in 1415, turning it into a young *Saint John the Baptist*.

1421
Donatello and Nanni di Bartolo carve the *Abraham and Isaac* for the campanile. It is placed on the east side along with *Joshua/John the Baptist* and the *Bearded* and *Beardless Prophets* in 1422.

c. 1422–8
Donatello and Michelozzo fashion the *Tomb of Baldassare Coscia*, the deposed antipope John XXIII, for the baptistery in Florence.

1423

First payment for the *Feast of Herod* for one of the six sides of the baptismal font in the baptistery in Siena. The other five episodes from Saint John the Baptist's life were commissioned from Ghiberti, Giovanni di Turino and Jacopo della Quercia.

1423–6

Jeremiah for the final (north) side of Giotto's campanile.

1426 c.–1427

Habakkuk ('*Zuccone*') for the same side, resuming and completing the work in 1435–6.

1426–8

Donatello and Michelozzo live in Pisa while working on the *Tomb of Cardinal Rinaldo Brancaccio* for the church of Sant'Angelo a Nilo in Naples. In 1426 Donatello witnesses two payments to Masaccio for the *Carmine Polyptych*.

1427

Donatello delivers the *Feast of Herod* for the baptistery in Siena.

1428

The architectural part of the Old Sacristy in San Lorenzo, begun by Brunelleschi in 1422, is completed. Donatello and his friend now set to work on the sculptural decoration, starting with the tomb of the founder, Giovanni di Bicci de' Medici.

1428 July 14

The Pieve (later the cathedral) of Prato commissions Donatello and Michelozzo to create the new exterior pulpit (finished in 1438) for displaying the Virgin's girdle, the city's most important relic.

1429

Donatello's *Faith* and *Hope*, two of the six bronze *Virtues*

for the corner niches of the font in the baptistery of Siena, are complete. Donatello also fashions three bronze *Spiritelli* to crown the tabernacle of the holy oil in the centre of the font (the other three are by Giovanni di Turino, 1431).

1429–30

He carves a *Dovizia* (*Abundance*) in *macigno* stone which is placed on top of a column in the Mercato Vecchio in Florence. Though destroyed by exposure to the elements, it appears in a handful of old pictures.

1430 summer

He travels through Rome, visiting the antiquities in humanist Poggio Bracciolini's home.

1432–3

He is again in Rome where he carves Giovanni Crivelli's tomb slab for Santa Maria in Aracœli and a eucharistic tabernacle in marble for Pope Eugene IV, for the altar of *Capella Parva* dedicated to the Blessed Sacrament in the Vatican Palace.

c. 1433–5

Macigno stone and terracotta aedicule with the *Annunciation* for the Cavalcanti family altar in Santa Croce in Florence.

1433–9

Cantoria (organ loft in the chancel below the dome) for Florence Cathedral, facing the *Cantoria* carved by Luca della Robbia (1431–8).

1434

Pope Eugene IV arrives in Florence, staying in the city with the Roman Curia until 1443 (with an interlude in Bologna and Ferrara, 1436–9). Cosimo the Elder returns from exile in October and becomes the arbiter of republican life.

Cartoon for the stained glass with the *Coronation of the Virgin*, completed in 1437, for the most important round window in the drum of the dome in the cathedral.

1435

In the dedication of his *De Pictura* to Brunelleschi, Leon Battista Alberti praises 'our very good friend Donato the sculptor' as one of the leading figures responsible for the renewal of art. He also lauds Ghiberti, Luca della Robbia and 'Masaccio' (the now long-dead painter, or possibly Donatello's assistant Maso di Bartolomeo).

c. 1435–40

Donatello returns to the decoration of the Old Sacristy, working on eight stucco tondi with the *Evangelists* and *Stories of Saint John the Evangelist*, and two niches above the doors with the *Patron Saints of the Medici*. A bronze *David* for the same family's 'Old House' in Via Larga (now Via Cavour) and the *Attis-Amorino*, possibly for the Bartolini Salimbeni, also date back to this period.

1438

A wooden *Saint John the Baptist* for the chapel of the Florentine colony in the basilica of the Frari in Venice.

1439 July 6

Bull of Union between the Roman and Greek Churches in the cathedral of Florence, where since the previous winter Pope Eugene IV, the patriarch of Constantinople and the Byzantine emperor have been attending the Council transferred to Florence from Ferrara.

c. 1440–2

Donatello carves the wooden *Mary Magdalene* for the baptistery and completes the

decoration of the Old Sacristy in San Lorenzo with two *macigno* stone portals and their bronze doors. This sparks a tiff with Brunelleschi who is irritated by the strong sculptural interference in the space he has designed.

c. 1440–5
Wooden *Crucifix* for the church of Santa Maria dei Servi in Padua.

1443 late–1444 early
Donatello moves to Padua where he is to remain for approximately eleven years (until 1454).

1444 January
The basilica of Sant'Antonio makes its first payments for the bronze *Crucifix*. Installed on the screen separating the congregation from the chancel in 1449, it is moved to the high altar in 1651.

1446 c.–1450
Donatello and a substantial team of assistants erect the large bronze, stone and marble altarpiece for the high altar in the basilica of Sant'Antonio. Dismantled in 1579, it is re-erected in a very different configuration in 1895.

1447
He completes most of the *Equestrian Monument of Gattamelata*.

1450
He is at the Gonzaga court in Mantua, working on the bronze tomb of Saint Anselm of Lucca for the cathedral, though he is never to complete it. He is in Ferrara in the autumn, possibly in connection with the bronze apparatus of the *Crucifix*, the two *Mourners* and the two *Patron Saints* fashioned by his pupil Niccolò Baroncelli, a Florentine, for the screen in the cathedral (1450–5).

1451
In Modena he agrees to produce a monument for Marquis Borso d'Este, though the project never comes to fruition.

1453
He is paid the balance for *Gattamelata*.

1454 September
From Faenza, Piero di Cosimo de' Medici announces the arrival in Tuscany of luggage belonging to Donatello. The artist may be travelling to Florence in the company of Bartolomeo Bellano of Padua, one of his closest assistants in the latter part of his life and recorded as being with him in 1456.

1456 August
The physician Giovanni Chellini of San Miniato mentions that his patient Donatello has made him a gift of a small bronze tondo depicting the *Virgin and Child*, now in London.

1456 autumn
Casting of the so-called *Carafa Head*, part of a bronze equestrian group of King Alfonso the Magnanimous for the triumphal arch entrance leading into the Castel Nuovo in Naples.

1457 summer–autumn
While working on the *Judith* for the Medici, Donatello flees to Siena where he is welcomed by the republican government with special honours and prepares to do a great deal of work for the cathedral. He brings with him the bronze *Saint John the Baptist* devoid of its right arm.

1458 August
Enea Silvio Piccolomini of Siena is elected to the papacy, taking the name of Pius II.

c. 1458
Madonna (known today as the

Virgin of Pardon) for the facade of the chapel of the Madonna delle Grazie in Siena Cathedral (destroyed in 1659).

c. 1459
In Florence, the bronze *David* is transferred to the centre of the courtyard in the new Palazzo Medici (later Riccardi) in Via Larga, on a base designed by Donatello and carved by Desiderio da Settignano.

1461
Donatello quits Siena without warning, leaving *Saint John the Baptist* devoid of its right arm. In Florence he lives in Via del Cocomero (now Via Ricasoli).

1461 c.–1466
He works with his pupils (including Bellano and Bertoldo di Giovanni) on completing the *Judith*, on the decoration of the courtyard and garden of Palazzo Medici and on the bronze chests for the two pulpits close to Cosimo the Elder's future tomb in San Lorenzo.

1464
The Opera del Duomo moves *Jeremiah*, *Habakkuk* and the other two *Prophets* from the north side of Giotto's campanile to the main facade facing the baptistery.
The dedication commissioned by Piero de' Medici for the column supporting *Judith* in the garden of his family palazzo bore the date 1464.

1464 August 1
Cosimo the Elder dies and is buried at the centre of the basilica of San Lorenzo, in the thickness of the pier that supports the vaults below the crossing.

1466 December 13
Donatello dies and is buried in the crypt of San Lorenzo, only yards away from Cosimo.

Photographic Acknowledgements
© 2021. Photo Scala, Firenze: p. 111 (fig. 1)
© 2021. Photo Scala, Firenze. Permission to reproduce material granted by the Ufficio Beni Culturali: p. 151
© 2022. Photo Opera Metropolitana Siena/Scala, Firenze: p. 133
© 2022. Photo Scala, Firenze: pp. 10–1
© Opera della Metropolitana Aut. n. 10/2022. Photo Bruno Bruchi: pp. 137, 146
© Opera della Metropolitana Aut. n. 10/2022. Photo LENSINI Siena: p. 147
© Opera della Metropolitana Aut. n. 978/2021: pp. 141, 144
© Opera della Metropolitana Aut. n. 978/2021. Photo Bruno Bruchi: pp. 8, 134–5
© Photo LENSINI Siena: p. 153
© Victoria and Albert Museum, London: pp. 46–7
Antonio Quattrone, Firenze. By courtesy of the Ministero della Cultura – Direzione regionale Musei della Toscana – Firenze: p. 24
Archivio Museo di Palazzo Pretorio, Prato. Filippo Tattini: p. 123
Archivio dell'Opera di Santa Croce (Foto SCALA Group – Firenze) / Thanks to the Direzione Centrale degli Affari dei Culti e per l'Amministrazione del Fondo Edifici di Culto del Ministero dell'Interno, proprietor of the Basilica di Santa Croce di Firenze: p. 49
Arcidiocesi di Firenze: p. 89
Bibliothèque nationale de France: p. 2, 118–9
By courtesy of the Ministero della Cultura – Direzione regionale Musei della Toscana – Firenze: p. 131
By courtesy of the Ministero della Cultura – Opificio delle Pietre Dure di Firenze: p. 104 (fig. 15)
By courtesy of the Opera di Santa Maria del Fiore/Antonio Quattrone: pp. 14, 17, 19, 21, 26–9, 31, 33, 35, 40–1, 156
By courtesy of the Opera di Santa Maria del Fiore/Bruno Bruchi: p. 39
By courtesy of the Opera di Santa Maria del Fiore – Franco Cosimo Panini Editore: p. 13
By courtesy of the Opera di Santa Maria del Fiore/Nicolò Orsi Battaglini: p. 45
Courtesy The Metropolitan Museum of Art: p. 37
Fondazione CR Firenze: p. 87 (fig. 1)
Fototeca Musei Civici Fiorentini. Photo Bruno Bruchi: pp. 87 (fig. 2), 115
Fototeca Musei Civici Fiorentini. Photo LENSINI Siena: p. 85
Fototeca Ufficio Beni Culturali Diocesi di Prato: pp. 126, 128
Museo Nazionale del Bargello, Firenze / By courtesy of the Ministero della Cultura. Photo Bruno Bruchi. Reproduction by any means is forbidden: pp. 22, 55, 57–8, 61–2, 64, 67, 68–9, 70, 72–6, 79, 81
Opera Medicea Laurenziana. By courtesy of the Ministero della Cultura – Opificio delle Pietre Dure di Firenze: pp. 94–6, 102–4, (fig. 14)
Opera Medicea Laurenziana. Photo Bruno Bruchi: cover, pp. 91, 93, 98–9
Opera Medicea Laurenziana. Photo Paolo Parmiggiani: p. 108
Paris, Musée Jacquemart-André – Institut de France © Anne Chauvet: p. 36
Photo Bruno Bruchi / Thanks to the Direzione Centrale degli Affari dei Culti e per l'Amministrazione del Fondo Edifici di Culto del Ministero dell'Interno, proprietor of the Basilica di Santa Croce di Firenze: pp. 6, 50
Photo Giovanni Martellucci: pp. 100, 113, 125
Photo Luca Lupi: p. 121
Photo George Tatge / Thanks to the Direzione Centrale degli Affari dei Culti e per l'Amministrazione del Fondo Edifici di Culto del Ministero dell'Interno, proprietor of the Basilica di Santa Croce di Firenze: p. 52
Staatliche Museen zu Berlin – Preußischer Kulturbesitz. Skulpturensammlung und Museum für Byzantinische Kunst. Photo Antje Voigt: p. 138

Cover
Donatello, *Saint George*, c. 1415–7, detail, Florence, Museo Nazionale del Bargello

pp. 2, 118–9
Girolamo Bellarmato, *Chorographia Tusciae*, a detail and the whole, c. 1550, Paris, Bibliothèque nationale de France

p. 6
Donatello, *Cavalcanti Altar*, c. 1433–5, detail, Florence, Santa Croce

p. 8
Donatello, *Feast of Herod*, 1423–7, detail, Siena, baptistery

pp. 10–1
Stefano Buonsignori, *Nova pulcherrimae civitatis Florentiae topographia accuratissime delineata*, 1594, detail, Florence, Palazzo Vecchio

p. 156
Donatello, *Cantoria*, 1433–9, detail, Florence, Museo dell'Opera di Santa Maria del Fiore

Graphic design and layout
Carmen Malafronte

Translations
Richard Sadleir

© 2022 by
Fondazione Palazzo Strozzi
© 2022 by
Marsilio Editori® S.p.A. in Venezia

First edition June 2022
isbn 979-12-5463-047-1

www.marsilioeditori.it

Colour reproduction
Opero s.r.l., Verona

Printed by
L.E.G.O. S.p.A., Vicenza
for Marsilio Editori® S.p.A. in Venezia